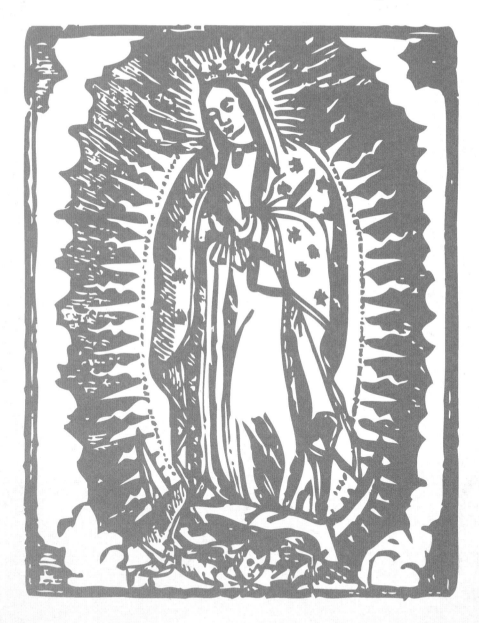

# the Virgin of Guadalupe

*Books by the Author*

PHOTOGRAPHY & ESSAY

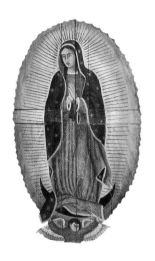

# the Virgin of Guadalupe
## ART AND LEGEND

*Written and photographed by*

# JOHN ANNERINO

**GIBBS SMITH**
TO ENRICH AND INSPIRE HUMANKIND

✠

*For my father, who first showed me the road to adventure,*
*For my mother, who always kept the candles burning,*
*For my wife, who brought a beautiful family into our lives,*
*And for my editor, who shepherded this book to you.*

First Edition
16 15 14 13        10 9 8 7 6 5 4 3 2

Text and photographs © 2012 by John Annerino
For photo permissions other than book reviews: www.johnannerinophotography.com

Published by
Gibbs Smith, Publisher
P.O. Box 667
Layton, Utah 84041

Orders 1.800.748.5439
www.gibbs-smith.com

Front cover location: La Paloma de Tubac, Arizona, used with permission.

Designed by Sheryl Dickert
Printed and bound in China
Gibbs Smith books are printed on either recycled, 100% post-consumer waste, FSC-certified
papers or on paper produced from sustainable PEFC-certified forest/controlled wood source.
Learn more at www.pefc.org.

Library of Congress Cataloging-in-Publication Data

Annerino, John.
  The Virgin of Guadalupe : art and legend / written and photographed by John Annerino. —
1st ed.
    p. cm.
  ISBN 978-1-4236-2471-4
  1. Guadalupe, Our Lady of—Art. 2. Guadalupe, Our Lady of. I. Title. II. Title: Art and legend.
  N8070.A556 2012
  704.9'4855—dc23
                                                        2011039877

# CONTENTS

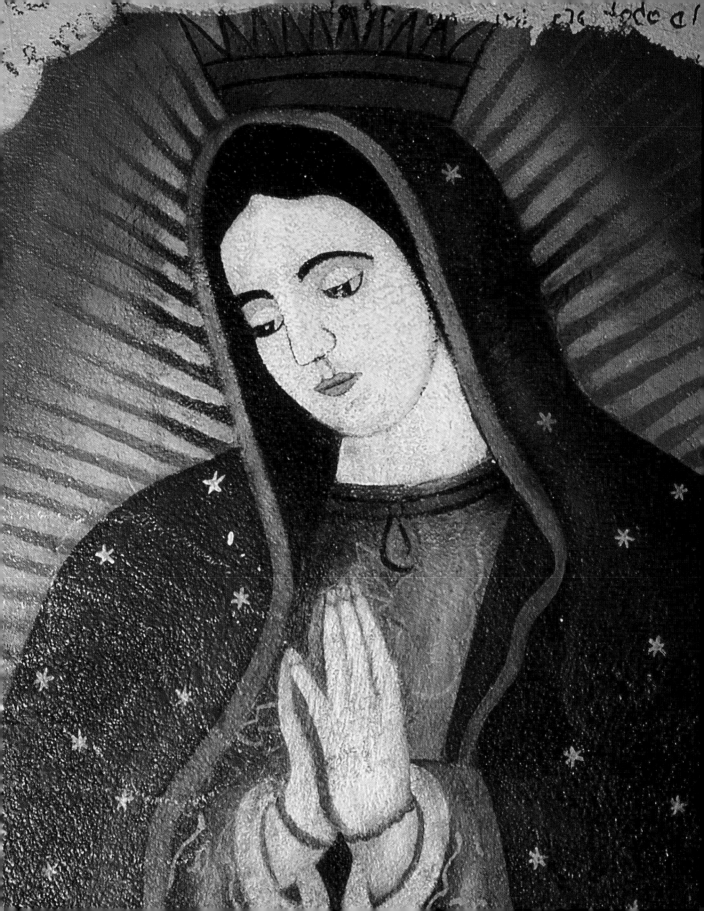

# A C K N O W L E D G M E N T S

This book would not have been possible without the dedication, insight, and guidance of many kind people who helped me realize a decade-long dream of producing a book on the beloved icon of the Virgin of Guadalupe. I am grateful to editor Madge Baird, book designer Sheryl Dickert, and design assistant Melissa Dymock at Gibbs Smith; translator and confidant Alejandrina Sierra, friend Lucinda Bush Garrett, and compañero Don Julio Reza Díaz for opening the secret doors along the *caminos* of Guanajuato; Señor Pedro Vistal Bustos and Doña Catalina López, who pulled back the veil on the sacred stones of *Las Carmelitas*; Luis Manuel and Beatriz Delgado Sierra, who showed me the street shrines and murals of their colonial pueblo; Juan Ramón Delgado, who showed me the byways of El Bajío, La Villa, and Mexico City; Mystical Theologian and Padre David José Beaumont, OFM Cap., Parroquia Nuestra Señora de Guadalupe, who lives that rare humble life of giving hope, love, and compassion to the Mountain Pima in the rugged *sierras* and *barrancas* of Sonora; Anthony V. Schwan for his grace; Bill Green, La Paloma de Tubac, Arizona, for his kind permission; Oscar Hermán Saénz for his generous technical support; and muralist Miguel Ángel Grijalva, artist Carlos Trujillo, and many other unknown *artesanos*, *costureras*, florists, folk artists, highway muralists, painters, sculptors, stone masons, tin smiths, and wood carvers whose work also graces the pages of this book. I am indebted to several people who opened their treasured private collections of the Virgin of Guadalupe to me: Mrs. Mary H. García, Menlo Park; Mrs. Ana María and Mr. Salvador Andrade; and Mrs. Josefina Lizarraga.

*LIFE* magazine director of photography Barbara Baker Burrows first opened my eyes to photographing iconic imagery by assigning me to mentor young Native American Pima students, many of whom picked up cameras for the first time to photograph their own impressions for the *LIFE* cover story "Children's Pictures of God."

The Virgin of Guadalupe, Highway 15 mural, Penasco Hill, Sonora, Mexico.
*La Virgen de Guadalupe, mural en la Carretera 15, Cerro de Peñasco, Sonora, México.*

7

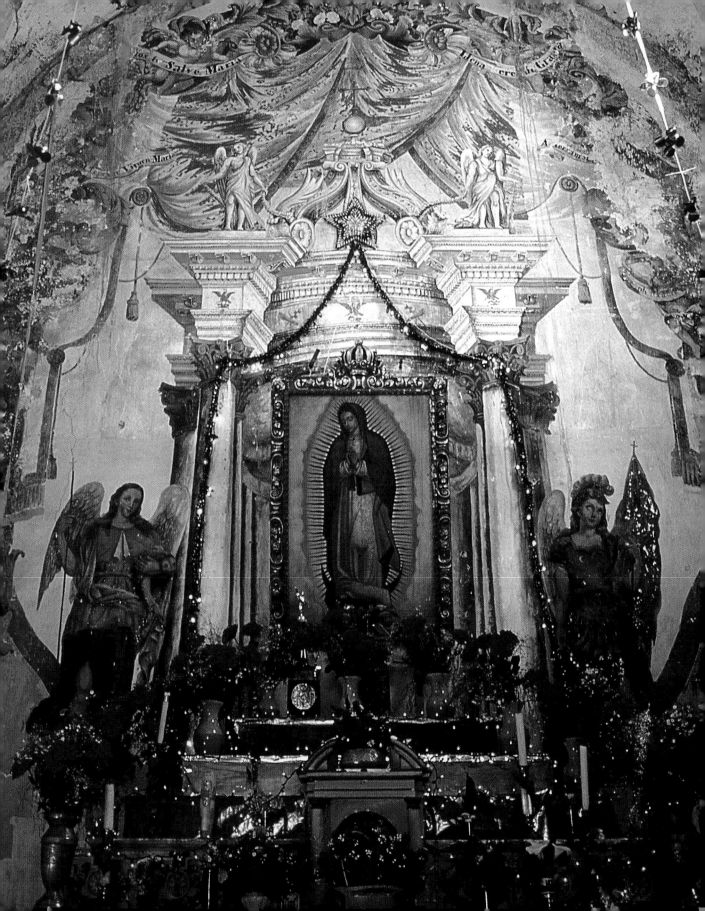

# HIDDEN MIRACLES

*"He [Juan Diego] heard singing on the little hill,*
*like the songs of many precious birds . . .*
*extremely soft and delightful;*
*He started to climb to the top of the little hill*
*to go see where they were calling him from."*

— ANTONIO VALERIANO, 1556,
from "Here It Is Told," *Nicān Mopōhua*, a "jewel of Náhuatl literature"

I'm climbing a cobblestone trail that winds around a mountain island into heavenly blue skies. Among the festive procession of people I'm following are sightseers who've ridden here in taxis, cars, and stake-side cattle trucks; vaqueros who've trod here on horseback; infants who've been carried here by mothers; pilgrims who've walked here on foot; and *campesinos* who've hobbled here on burros. Many were called to this storied mountain to see *El Cristo Rey*, "Christ the King." A landmark bronze statue that towers high above the mountain called *El Cerro del Cubilete*, it was built in honor of the *Cristeros*, Christian rebels, who carried a green, white, and red flag of the Virgin of Guadalupe into battle, proclaiming a faith for which many were martyred.

The trail began in the small pueblo of Aguas Buenas, Mexico, near the foot of the mountain at the shrine of *El Templo de Santa María Reina de los Mártires*, "Saint Queen Mary of the Martyrs Temple." Visitors often stopped here to pray before beginning their steep peregrination, drawn by an altar of the Virgin of Guadalupe that was adorned with red roses, archangels, and the colors of Navidad. I am among them on this beautiful winter day, captivated by the dreamy landscape that stretches

The Virgin of Guadalupe, altar, Saint Queen Mary of the Martyrs Temple, Aguas Buenas, Guanajuato, Mexico.
*La Virgen de Guadalupe, altar, El Templo de Santa María Reina de los Mártires, Aguas Buenas, Guanajuato, México.*

beneath us as we climb higher and higher to the foot of El Cristo Rey. At 8,640 feet above sea level, El Cubilete is dwarfed by Mexico's highest mountains, a ring of supernal snow-capped volcanoes revered by the Aztecs as *Citlaltépetl,* "Mountain of the Star," *Popocatépetl,* "Smoking Mountain," and *Iztaccíhuatl,* "Sleeping Lady." The geographical center of Mexico, El Cubilete offers a commanding view of *El Bajío,* "The Lowlands," of the Cordillera de Anáhuac, a fertile volcanic plateau that arcs midway across the republic from the Gulf of Mexico to the Pacific Ocean.

From my aerie, I stare north across the oak- and pine-covered mountains of the Sierra de Guanajuato and retrace the historic silver roads far beyond the horizon. A week earlier I had departed from El Paso, Texas. That's where my family and I often began our travels down El Camino Real de Tierra Adentro to celebrate Navidad in Guanajuato. Where Spanish colonists once endured an arduous three-month journey on burro-drawn wooden carts and ox-powered wagons, we traveled by train, truck, or bus, following the southern leg of the 1,600-mile-long Royal Road of the Interior Lands from Ciudad Juárez to Chihuahua, Durango, Zacatecas, Aguas Calientes, Lagos de Moreno, and Guanajuato. In the heyday of the Royal Road, which linked the Royal Mint in Mexico City with the capitol of Santa Fe, New Mexico, these precolonial and colonial cities bustled with haciendas, missions, *mercados, presidios,* and the richest silver mines in the world.

Perched on a breezy overlook on the rim of El Cubilete, I traced the myriad roads that branched off the southern reaches of the Camino Real that created their own histories, legends, and songs. Some were made famous in José Alfredo Jiménez's heart-wrenching ballad to his home and *paisanos, Camino de Guanajuato*: "The road to Santa Rosa, the Sierra of Guanajuato, there just behind the hills, you can see Dolores Hidalgo. There I'll stay, my countrymen. My beloved town is there."

Over the years, I've had the good fortune to follow those caminos in many directions. I stood in the church plaza of Dolores Hidalgo and recalled the impassioned voice of revolutionary priest Miguel Hidalgo y Costilla invoking *El Grito de Dolores,* "The Cry of Dolores," in the name of Mexican Independence to throngs of peasants, mestizos, and *hacendados* (hacienda owners). I wandered the narrow colonial streets and romantic Callejón del Beso of the capitol of Guanajuato, startled to see the haunting faces of *las momias,* "the mummies," the children still dressed as angels and saints. I paid my respects at the tomb of José Alfredo Jiménez, one of Mexico's greatest *ranchera* singers, where he lay buried beneath a monumental sombrero and sarape at the foot of the Sierra de Guanajuato. I explored every camino throughout the *Cuna de la Independencia,* "Cradle of Independence," that fed

my wanderlust and curiosity, struck by the rich history, living traditions, and kind-hearted people.

None was more mystifying to me than the camino that lead to the small *ejido* of Lo de Juárez. I didn't know it at the time, but this *jornada* inspired my quest to rediscover the Virgin of Guadalupe.

It was a balmy winter morning when we walked down the dusty streets of the old pueblo to the songs of crowing roosters. A line of women stood in front of the *tortillería*, each patiently waiting to buy a kilo of warm corn tortillas. Children laughed and played in the small church plaza. And a burro ambled by, packed with a load of firewood, led along by an old *campesino*. My friend Julio Reza Díaz and I had come to visit his friend, a caretaker at an ex-hacienda nearby. But I first wanted to stop and look inside the small church across the road.

We pushed open the heavy wooden doors. The long, crypt-sounding screeching broke the silence and sunlight sliced through the darkness, illuminating the church's musty interior. Paint and stucco was peeling off the crumbling walls, exposing adobe bricks that dated back to the eighteenth century. A row of votive candles flickered beneath a large rustic-framed picture of the Virgin of Guadalupe, accenting the narrow shafts of light that peered through the small windows overhead. Several old women were kneeling amongst the wooden pews. Covered in black head scarves and shawls, they whispered in prayer, *"Padre nuestro, ques estás*

*en el cielo . . . ,"* clasping black beaded rosaries that dangled from their withered hands. The silence and feeling of reverence was palpable and inviting. I often sought solace in such humble places throughout Mexico where I could sit and contemplate the moments, or just close my eyes and relish the peace.

I motioned to Julio that I was going to sit down, when a faded black-and-white photo caught my eye. It was hanging from a rusty horseshoe nail, its antique wooden frame held together with cobwebs. Beneath the cracked glass was a split stone. A mirror image of the Virgen del Carmen adorned both halves of the same stone. That was strange, I thought. I motioned to Julio, asking him in silence if he knew what they were?

He tiptoed through the pew and leaned over one of the women saying the rosary. He asked in a whisper if she knew where the stones were kept. She looked up at him. Deep lines etched her face and her dark eyes pooled with hope. She pointed with a crooked finger. "Over there," she said quietly in Spanish. "They are in the other church. But you must ask Señora López to open the doors. She's the only one who has the key." The woman looked back down over the hand-worn wooden railing of the pew and resumed polishing the black rosary beads with her fingers, whispering *"Santa Maria, Madre de Díos, ruega Señora por nosotros . . ."*

As Julio and I walked out of the old church,

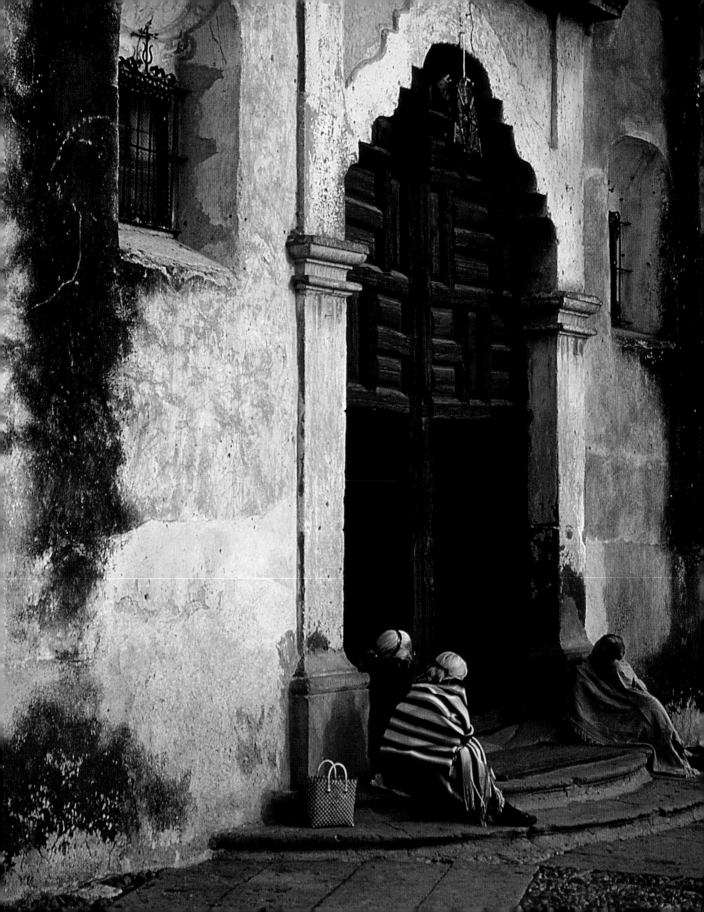

a man I hadn't noticed before emerged from the shadows and followed us outside. He had apparently overheard our whispers. His name was Pedro Vistal Bustos. He said that we could photograph the photograph of the Virgins del Carmen if we wished. But I knew that would not work. Since I'd first met Julio, he had proven to be a Don Juan Matus, "a man of knowledge," who guided me throughout the Bajío to feed my inquisitiveness and to show me what he called *México Mágico*, "Magic Mexico." His friendly charm had often worked its own magic, opening secret doors that would have otherwise remained closed. Julio explained to Señor Bustos that we were photographers—and that we certainly knew how such photographs were faked. Sr. Bustos, an amiable but diplomatic man, agreed to show us the stones, if we would first listen to the story of José María Galicia. We agreed.

The bent figure of a weary *campesino* is chipping away at the sunbaked stones. He is wearing leather huaraches, ragged cotton pants, and a loose-fitting muslin shirt. A sarape hangs over one shoulder and a tattered straw sombrero covers his head. His burro is hitched to an olive tree, and his lunch of corn tortillas, beans, chiles, and pieces of sweet coconut candy hangs from a sack dangling from the burro's pack harness. He has been pounding and prying apart the stubborn rocks piece-by-piece for many years, wielding the heavy iron bar in his calloused hands with the skill of a mason. José María Galicia is a *calero* (caliche miner), and he excavates limestone that will be gathered in burlap sacks his burro will carry to the hacienda's *horno de cal* (lime kiln). The stones will be heated for a day and a half and processed into quick lime used for construction and for preparing *nixtamal* for making corn tortillas and Guanajuato's hearty beef, hominy, and red chili stew called *pozole*.

José María is strong, light and agile, but he has grown weary over the years from the thankless work and peon's wages. He is chipping away at the rock when a small stone rolls over his foot. He stoops down, tosses it back in the heap and resumes the slow, tortuous work of prying apart the hard slab. The fist-size stone rolls over his huarache again. He tosses the stone back into the heap, muttering *"Madre de Dios,"* only to watch in disbelief as it rolls back down over his calloused feet. Impatient, he pushes the sombrero back on his head and smashes the stone with the iron bar, splitting it in half.

When he glimpses the Virgen del Carmen mirrored on opposite faces of the cleaved stone, he drops to his knees, bows his head to the ground, and begs forgiveness, *"Perdoname Santísma Madre María."* The date was February 14, 1792.

Jesus of Nazareth Sanctuary, Atotonilco (Sanctuary of God and Country), Guanajuato, Mexico.

*Santuario de Jesús Nazareno de Atotonilco (Santuario de Díos y de la Patría), Guanajuato, México.*

By the time we reached the small adobe home of Doña Catalina López, Sr. Bustos had finished his story. He introduced us to Señora López. She opened the rickety wooden screen door and agreed to take us to the new church. She had been guarding the sacred stones for the many years, and she alone was responsible for unlocking the doors to their sanctum.

When we entered the dark cavern of the church, Julio and I were instructed to wait in the dim light in front of the altar. We looked at each other in disbelief as Sra. López and Sr. Bustos entered the pitch-black vestibule.

Señor Bustos returned with a worn, dust-covered shoe box and carefully placed it on the altar. Sra. López trailed behind, holding a lighted candle. He removed the lid from the box and blew off the thick layer of dust. Julio and I peered inside. We couldn't see anything but wrinkled paper. Sra. López set the candle on the altar, slid her hands into the box, and gingerly uncovered the stones. My heart began racing. She clutched the stones, one in each hand, and held them out for us to view. They were opposite halves of the same stone, and each carried a delicate mirror image of the Virgen del Carmen.

I glanced at my friend Julio, but the glint in his mischievous brown eyes told me he was already thinking the same thing. He politely suggested a photo to Sr. Bustos: a quick snapshot, nothing more, certainly nothing grandiose. Julio is a widely respected photographer. The Bajio is his home. But Sr. Bustos told us it was impossible and nodded to Sra. López to put the stones back in the box. Julio tried another tack, the stones were so close.

"*Mi amigo Juan,*" Julio began, "he has journeyed very far. Where he comes from, the people don't see such miracles. Certainly, this one time, the *Norteamericanos* can see a little miracle—with your generous help, of course?"

Sr. Bustos looked at me. I looked at him. My eyes told him I could not believe what I was seeing.

The amiable Sr. Bustos nodded his head to us. He agreed to help us show the *Americanos* a miracle, but only on the condition that the name of the pueblo and church not be disclosed. (See footnote in Literature Cited). He feared officials would return again with documents and try to take the stones away and cart them off to a distant museum in Mexico City.

Señora López sat on the steps in front of the church, clutching a stone in each hand. We went about our work, carefully photographing the thin black-line images on both stones. I was awed. I'd never seen anything like these stones before. Nor had I ever been privy to photograph what many accept as a miracle. I asked Sra. López what she thought.

"*Es un milagro* (It's a miracle)," she said simply.

We thanked her and Sr. Bustos. The smile on his face told me he had taken great pride in being able to help us show the *Americanos* a miracle. He would

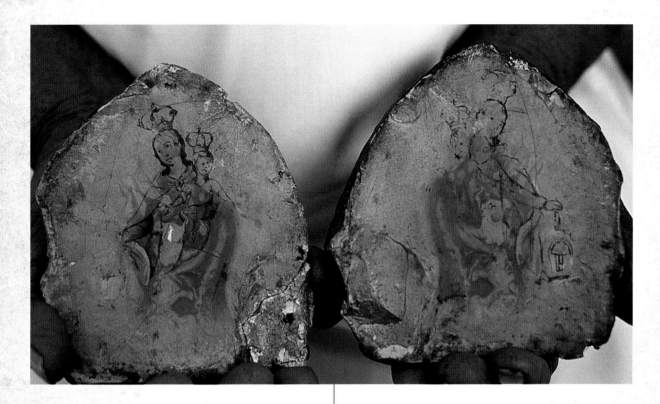

not take any money for the privilege he alone had granted us to view and photograph what he endearingly called *Las Carmelitas,* "the Little Carmens." With quiet reverence, Sra. López carefully returned them to their sanctuary, and the location died in my memory. But as Julio and I walked down the narrow path, I asked him what he thought. Julio smiled and said to me in Spanish, "We went looking for water today, my friend, and discovered oil instead."

I didn't know what to think. I didn't know if we had just photographed the miraculous or if it was something else altogether.

In Willa Cather's endearing 1927 novel *Death Comes for the Archbishop,* she wrote, "Where there is

The Virgin of Carmen, sacred stones discovered by limestone miner Jose Maria Galicia, the Virgin of Carmen Church, Lo de Juarez (Manzanilla), Guanajuato, Mexico.

*La Virgen del Carmen, piedras sagradas encontradas por el calero José María Galicia, Iglesia de La Virgen del Carmen, Lo de Juárez (Manzanilla), Guanajuato, México.*

great love there are always miracles . . . One might almost say that an apparition is human vision corrected by divine love. . . . [They] seem to me to rest not so much upon faces or voices or healing power coming suddenly near to us from afar off, but upon our perception being made finer, so that for a moment our eyes can see and our ears can hear what is there about us always."

There must have been great love in the heart of José María Galicia. He finally saw "what had been there about him always." And he kept his promise to build a church on this hallowed ground in the dirt-poor *ejido* of Lo de Juárez, Guanajuato, to shelter the sacred stones of Las Carmelitas. What very little is known about Sr. Galicia, even less is popularly known about Las Carmelitas. There is no record of the stones speaking to José María Galicia in a mystic appearance or in a miraculous apparition. But the hallowed relics had withstood 220 years of pious scrutiny.

Were Las Carmelitas what Greek scholars classified as *acheiropoieta*, a Byzantine word used to describe religious relics and icons "not made by hand" that miraculously appeared on stone columns, cloth, and paintings? Were the sacred stones of Las Carmelitas made by human hands? Did a *calero*, masterfully wielding the colorful quill of a macaw feather traded by the indigenous Chichimeca, using ink produced from natural dye and chimney soot from the hacienda's lime kiln, enhance the Marian ghost image visible beneath the right half of Las Carmelitas? I did not know. If Las Carmelitas were not made by human hands, shouldn't they rank alongside the world's powerful religious icons officially recognized as having miraculously appeared, such as the Shroud of Turin, Image of Edessa, Veil of Veronica, or the Virgin of Guadalupe on the *tilma* (poncho) of Juan Diego?

If possible, I wanted to find an answer. So I went to Mexico City to visit a hill called Cerro de Tepeyac to see where the Virgin of Guadalupe had first appeared before Juan Diego in 1531, which is revered as a miraculous apparition. Juan Diego's description of the Virgin of Guadalupe was later recounted in an ancient Aztec text that had been discovered in the New York City Public Library. It was called *Nicān Mopōhua* ("Here It is Told") and was written by Antonio Valeriano in 1556. In his native Aztec language, Valeriano wrote:

> *Her perfect grandeur exceeded all imagination: her clothing was shining like the sun, as if it were sending out waves of light, and the stone, the crag on which she stood, seemed to be giving out rays; her radiance was like precious stones, it seemed like an exquisite bracelet [it seemed beautiful beyond anything else]; the earth seemed to shine with the brilliance of a rainbow in the mist.*

Valeriano's recounting of the wonderful story of a beautiful young woman who appeared to a humble peasant on Cerro de Tepeyac only ten years after Spanish conquistador Hernán Cortés had vanquished the Aztec empire in nearby Tenochtitlán is recognized as one of the finest examples of Aztec literature. Franciscan priest, linguist, and ethnographer Bernardino de Sahagún interviewed the Aztec over many years, and they assured him

Tepeyac was the site of their sacred temple to the goddess Tonantzín, "Our Revered Mother." In Valeriano's account, Juan Diego was lured by songbirds to a hilltop covered with a dazzling array of flowers. The young woman Juan Diego called "My Beloved Maiden" spoke to him. In her heavenly voice she beseeched "her little son" Juan Diego to ask Juan de Zumárraja, the archbishop of Mexico City, to build a shrine in her honor atop Cerro de Tepeyac. But the Spanish bishop repeatedly resisted Juan Diego's timid pleas. And he asked Juan Diego to bring him proof of the incredible stories he had been telling him. Distraught that he might offend the Maiden with bad news, Juan Diego was instructed by her to cut and gather the brilliant-colored flowers that were then blooming on the winter hillside. When Juan Diego returned with the flowers, the Maiden took them ". . . with her precious hands; then she put them all together into the hollow of his *tilma* again and said, "My youngest and dearest son, these different flowers are the proof, the sign that you will take to the bishop." Juan Diego returned to the bishop's house and opened his *tilma* before him. Roses fell at the bishop's feet, unveiling the miraculous image of Our Lady of Guadalupe. The bishop dropped to his knees in disbelief and begged for forgiveness. Six years later, eight million Aztecs and *mestizos* were baptized after embracing the miraculous apparition.

On the four-hour drive from Guanajuato to the fifth largest city on earth, I daydreamed of seeing the sacred *tilma* of Juan Diego, who had since been canonized as Saint Juan Diego Cuauhtlatoatzin.

I longed to see the volcanic crags of the Cerro de Tepeyac, the forested hills of the Sierra de Guadalupe, and the tranquil waters of Lake Texcoco of the sixteenth-century Aztecs. But the Sierra de Guadalupe I saw when I arrived early the same afternoon is now called El Tepeyac National Park. The native pine forests had been replanted with eucalyptus trees and shared the sacrosanct domain of the Aztec with *la villa*, "the town." A sprawling complex covering six *colonias* in the heart of Mexico City, La Villa included the *Capilla del Cerrito*, "Chapel on the Little Hill," where the Virgin of Guadalupe appeared before Juan Diego; the *Capilla del Pocito*, "Chapel of the Little Well," built over sacred waters; *parroquia de las capuchinas*, "a Franciscan nuns' church"; *parroquia de los Indios, San José de los Naturales*, the "Indian" church; *el Bautisterio*, "the Baptistry"; and the edifice of the ancient basilica that listed in the ancient lake bed of Texcoco like the Tower of Pisa. Replaced by *Basílica Nuestra Señora de Guadalupe*, "Our Lady of Guadalupe Basilica," the modern basilica is one of the most visited shrines in the world, attracting 15 million tourists and devotees each year. On the December 12 Feast Day of Guadalupe alone, an estimated two to three million Guadalupanos visit La Villa during their annual pilgrimage to the Virgin of Guadalupe.

Climbing up the tile steps to the Chapel on the Little Hill I stopped beneath a vine-covered arch and looked back down the long stairway. When English world traveler Ethel Alec-Tweedle penned *Mexico, As I Saw It* in 1901, she wrote:

> At the back of the principal church is a strange stairway . . . walls cracked by earthquakes . . . leading to the Chapel on the Hill. This ascent is composed of very wide stone steps, of which there are some hundreds . . . It is up these steps devout pilgrims crawl on their hands and knees.

From her vivid descriptions it was easy to imagine hundreds, if not thousands, of poor *campesinos* and indigenous people slowly making their way up the steep stairway in the hallowed footsteps of Juan Diego, after having walked hundreds of miles to the foot of Tepeyac.

On this day, I see a half dozen photographers, many tourists and visitors, and school children dressed in neatly pressed uniforms. I ask one of the photographers if the *tilma* of Juan Diego was visible in the chapel above. He was carrying a portable altar of the Virgin of Guadalupe, enshrined in plastic flowers, that he used as a backdrop to photograph visitors. He shook his head "no," and pointed to the basilica far below. I had to drive back to Guanajuato that night, so I turned around before reaching the Little Chapel on the Hill and joined the long line of visitors inching through the grand basilica. Built to seat 10,000 people, with standing room only for another 40,000, I suddenly found myself longing for the little church of Lo de Juarez. When I finally reached the altar an hour or so later, I peered at the *tilma* twenty to twenty-five feet above. Framed in silver and gold, and protected under thick ballistic glass, it was difficult to discern the details of what priest and theologian Miguel Sánchez described in 1648 as the Woman of Apocalypse: "[There] appeared in the sky a great signal; a woman clothed with the sun and the moon under her feet, and on her head a crown of twelve stars."

I sat down in the pew and reviewed my notes, occasionally glancing at the *tilma*; it was so close but so far away I could not discern the details of the most revered religious icon in the world. Scientists, scholars, clergy, artists, photographers, apparitionists, and skeptics studied and repeatedly tested both the *tilma* and the image of the Virgin of Guadalupe. When indigenous Zapotec artist Miguel Cabrera was given permission to paint three copies of *Nuestra Señora de Guadalupe de México*, "Our Lady of Guadalupe of Mexico," in 1752, he later testified in his book *Maravilla Americana (American Marvel)*: "It is unmatched, and so perfectly finished, and marvellous, that I'm fully certain that whoever with the elementary knowledge of the principles of this art, on seeing it, will exceed in eloquence to make this portent known as miraculous." Three feet four

inches wide and five feet six inches tall, the hand-woven tilma was made from maguey fiber and had withstood 481 years of natural decay.

The imprinted *acheiropoieta* (items not made by hand) image of the Virgin of Guadalupe was a codex that included important Aztec symbols. The sun's rays had been variously interpreted to represent the pointed leaves of the maguey, which inspired the name "Mother of the Maguey," and the birth of the sun god Ipalnemohuani ("One for Whom We Live"), and Ometéotl (a "God with Two Natures"). The turquoise mantle was a color reserved for emperors—the Aztecs considered the Virgin an empress. Difficult to fathom as a coincidence, the celestial alignment of the mantle's forty-six eight-pointed stars represented the constellation as it was on December 12, 1531. The four-petal flower *Ollín nahui* (Aztec flower symbol) above the womb on the Virgin of Guadalupe's tunic represented the "Mother of the Sun Child." A hand-carved petroglyph of the symbol can still be seen at the Cuailama Hill Ceremonial Center in nearby Xochimilco. The black ribbon around her waist was a maternity band worn by indigenous women. The nine eight-petal *tepetl* flowers represent the "flower of the heart" that the Aztec called *yolloxochitl* ("heart" and "flower"), which symbolized those sacrificed for the goddess Tonantzin.

The Virgin of Guadalupe's compassionate face was described as a sixteen-year-old *mestizo* girl, who, with hands clasped in prayer, gave birth to and joined together a peaceful new ethnicity of Aztecs and Spaniards. In 1979, scientists magnified the irises of the Virgin's eyes 2,500 times and wrote that they reflected the iridescent images of thirteen people, including Juan Diego and Bishop Juan de Zumárraga.

This was the compassionate, lovely, miraculous, revered, and oft debated image, miracle, and myth that I followed from the gates of the Basilica de Guadalupe that day into the crowded streets of the Calzada de Guadalupe outside La Villa. Stalls, vendors, and *tiendas* offered myriad renditions of the Virgin of Guadalupe wherever I looked. La Villa was both the birthplace and crossroads for the Virgin of Guadalupe, which traveled in many directions around the world, first by ship in 1541 when Admiral Giovanni Andrea Doria carried a copy of the Virgin of Guadalupe onboard when he defeated Ottoman Turks in the Battle of Lepanto in the Mediterranean Sea. The iconic image has since been embraced around the globe from Puerto Rico to Argentina, the Philippines, the United States, St. Peter's Basilica in the Vatican, and beyond. Only three miles south of La Villa, legendary Mexican photographer Augustín Victor Casasola photographed a group of revolutionary Zapatistas riding horseback through El Zócalo, Mexico City's main square, carrying a banner of the Virgin of Guadalupe. They rode under the command of General Emiliano Zapata, who led his indigenous

troops throughout the war-torn republic to defend their land and liberty.

Driving north along the Camino Real through the Sierra Gorda of Querétaro to Guanajuato, I followed a road that was also known as the *Ruta de la Independencia*, "Route of the Independence." It wound through the forested mountains, mesas, and plains of northern Guanajuato to the Spanish colonial city of San Miguel de Allende. The next morning, I revisited the San Miguel Archangel Parochial Church. Recognized for its Baroque Neoclassical architecture, it was one of the most magnificent churches in all of Mexico. Revolutionary Miguel Hidalgo y Costilla, later trumpeted as the "Father of the Nation," served as a priest here before he was defrocked, excommunicated, executed by a Spanish firing squad, and beheaded for inciting the insurgent rebellion that sparked the Mexican War of Independence. Hidalgo's troops had also marched into battle under the banner of "Santa María de Guadalupe." Hidalgo's faith had no doubt inspired the side altar inside the San Miguel Basilica. Etched in my memory, it depicted a near life-sized statue of Juan Diego kneeling before a gold leaf–framed painting of the Virgin of Guadalupe. This was one of the images I imagined I would see in La Villa.

Standing before the altar of Juan Diego and the Virgin of Guadalupe later that morning was a turning point for me. Where before I had photographed the Virgin of Guadalupe by chance, I now planned to follow and photograph this extraordinary image and its many renditions and manifestations as a religious symbol and as a popular cultural icon in hopes of compiling a collection of reverent depictions of the Virgin, and other Marian figures associated with her, that adorned cathedrals, churches, sanctuaries, missions, chapels, stained glass windows, home altars, roadside shrines, caves, paintings, statues, dioramas, vitrinas, votive candles, scapulars, folk art, souvenirs, clocks and treasured private collections.

My journey led me in many directions. From Guanajuato, San Miguel de Allende, and the Sanctuary of Atotonilco, I journeyed to the Mayan sanctuaries in the jungles of Yucatan, explored the lost missions and hidden barrancas of the Sierra Madre Occidental in Chihuahua, and ventured along the desert paths of the *Jornada del Muerto*, "Journey of the Dead Man," in New Mexico and the Camino del Diablo (Road of the Devil) in Arizona.

Some depictions were impossible to photograph, though they helped provide me with a deeper understanding of the Virgin of Guadalupe's image, those who revered it, and the power of hope, promise, and inspiration it held for millions of people around the world.

One summer I set out to explore the Camino del Diablo on foot. I wanted to experience firsthand what tireless Jesuit missionaries like Padre Eusebio Francisco Kino had seen and endured during their

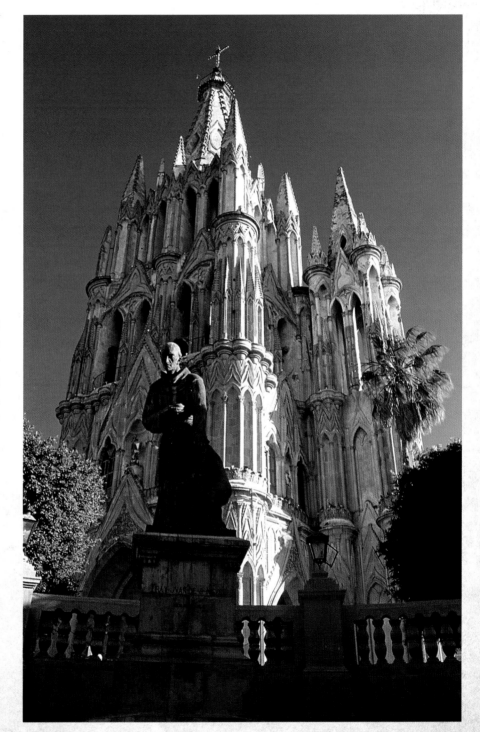

San Miguel Arcangel Parochial
Church, San Miguel de Allende,
Guanajuato, Mexico.

*La Parroquía de San Miguel*
*Arcángel, San Miguel de Allende,*
*Guanajuato, México.*

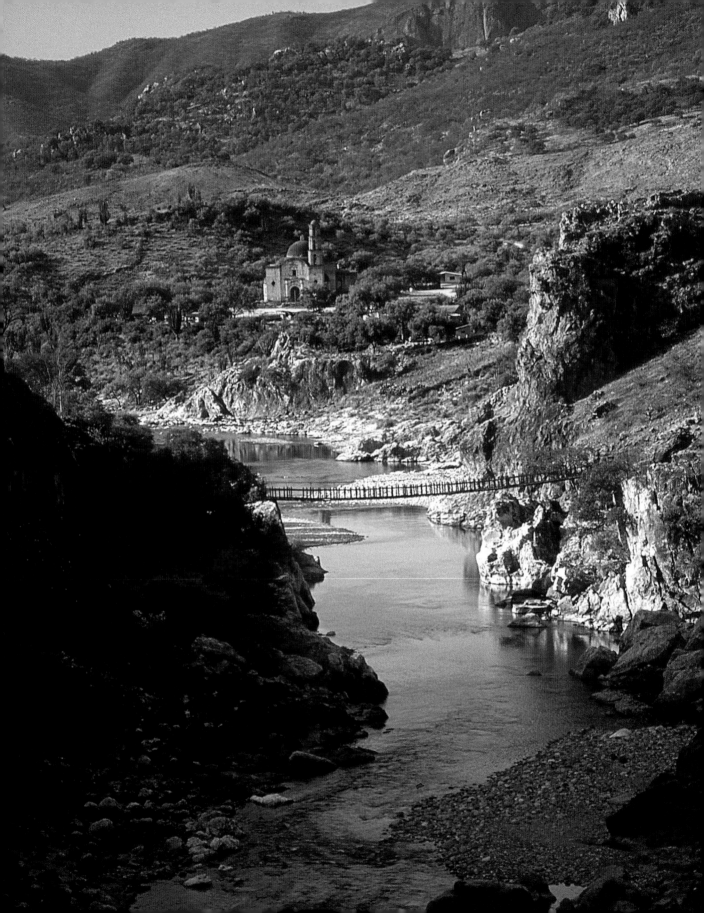

remarkable journeys through merciless deserts. The only people who dwelled in what pioneers and forty-niners later cursed as hell on earth were the indigenous Hia Ced O'odham (People of the Sand), who roamed the Empty Quarter of southwestern Arizona and northwestern Sonora on a never-ending quest for food and liquid, which they harvested from natural sources to sustain them in one of the harshest deserts on earth. Everyone else was just passing through—if they could survive the journey.

Many did not. The dry winds of the largest sand sea on the continent blew across the forlorn trails of missionaries, California-bound emigrants, and gold seekers. Their rough, often waterless, journeys fomented apparitions of a mysterious Lady in Blue. She was later identified as Franciscan nun Sor María de Jesús de Ágreda. When the renowned mystic was interviewed in Spain in 1631 by Fray Alonso Benavides about her travels through the deserts of New Spain, the venerable nun vowed she'd had hundreds of trance-induced bilocations from Spain and that she had ministered to the Indians in the deserts of West Texas, New Mexico, and Arizona between 1620 and 1631. Church investigators did not want to believe such raptures, but the

The Lost Mission of the Sierra Madre, Saint Arcangel de Guadalupe of Satevo Mission, Chihuahua, Mexico.

*La Misión Perdida de la Sierra Madre, Misión de Santo Arcángel de La Guadalupe de Satevó, Chihuahua, México.*

Jumanos of New Mexico confirmed they had been taught by the "Woman in Blue." She had received a calling and she traveled on the winds of God. Some believe her benevolent spirit still floats across the mysterious desert hinterlands.

One hot, windy day, I was weary, dehydrated, and dragging my feet back to a mountain cave that served as my camp during a self-imposed exile to count desert bighorn sheep for an annual survey in the grimmest reaches of the Sonoran Desert. I would have sworn I saw the Lady in Blue shimmering in a mirage amongst the dust devils that danced and whirled on the horizon among towering thunderheads that drilled the distant desert sierras with blue lightning, just as I had previously read in a book:

> *He was exceedingly tired and sore of foot, and was in such a state that he was prepared to die. Then he saw before him the Blue Lady, beckoning him on. He stumbled along after her, and after awhile she stopped. When he came up he saw, beside her, a spring of fresh water, and he fell on his breast and drank his fill . . .*

I had clearly seen her dreamy image, but the Lady in Blue did not talk to me. After I staggered through the hot dunes back to my cave, I later realized I was experiencing what I perceived to be her reverent image in the natural world, what's called *simulacra*, or similarity.

Another time, I was walking through the desert under far more pleasant conditions. Not seventy-five yards in front of me, I saw the image of the Virgin of Guadalupe hovering amongst towering green saguaro cactus, palo verde, and mesquite trees. I had just edited the collection of photographs for this book, so I understood I was perceiving her image that was often in my thoughts, dreams, and actions. But a strange and wonderful thing happened a week later. I was praying in the desert, as I sometimes do in what traditional Native Americans view as the dwelling place of the Great Spirit. I was praying for a sign about a difficult decision I'd made that still weighed heavily on me—any sign: an eagle, a coyote, a gust of wind. After a week, I gave up and figured the powers that be had far more pressing matters than my worldly concerns. For some reason, I looked down directly in front of my feet as I was walking along the desert path instead of watching the trail fifteen to twenty feet in front of me. A gold gem was glistening in the warm sand and decomposed rocks. I stooped down and picked up a tiny medal. It was the size of my small fingernail. On one side was the Virgin of Guadalupe; on the other was the face of God. The *tilma* of Juan Diego *and* the Shroud of Turin?

Whoah.

A wave of calm came over me. I was awestruck. Were it not for the sharp rocks, I might have dropped to my knees. I didn't know what to think and was afraid to tell anyone.

Had I experienced the miraculous? Could it have possibly been an extraordinary coincidence? After eighteen years of running and walking on the same desert footpath day in and day out, I suddenly found the tiny gem nearly the same week I'd prayed for a sign just one hundred twenty-five yards away from the very spot where the gem glistened like a gold nugget. What were the odds of that happening to anyone? Had José María Galicia been looking for a sign to lift him out of poverty when he discovered the sacred stones of Las Carmelitas?

As I finish writing this, the desert gem sits atop my laptop, no bigger than the gray keys I gently strike with my fingertips, I still wonder how I can return it to its rightful owner.

This book features many of the images I was privileged to take during those journeys and the enlightening experiences and perceptions I had. Included here are evocative quotes from mystics, novelists, revolutionaries, singers, poets, priests, popes, and Aztec musicians, who in turn were inspired to share their own experiences, feelings, and passions about the ever beloved Virgin of Guadalupe, known as the Mother of the Americas.

The Virgin de Guadalupe, a color print on blue poster board, private collection, JL.

*La Virgen de Guadalupe, retrato en un poster sobre fondo azul, colección privada, Jl.*

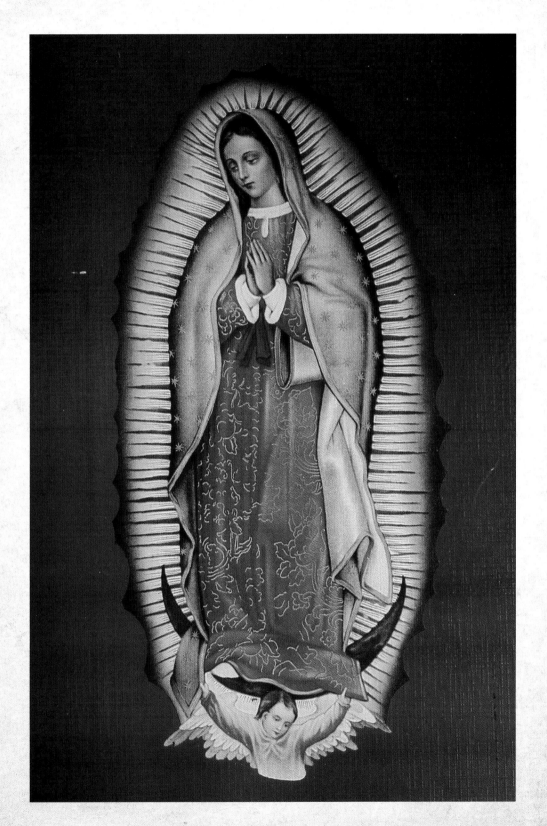

✝

# A MEXICAN FOLK SONG

"Just listen to me, Sirs,
I'd like to sing you a song,
It's something that really happened:
I wouldn't string you along . . .
It's the token that you asked for
The loveliest flowers that there've been,
With a freshness and a savor
That the world has never seen.

Juanito dropped his cloak then,
Let the roses fall
And disclosed Our Lady's picture:
Mother of sinners all.
All dropped to their knees then
At this miracle serene,
Crossed themselves and shouted,
"Long live the Indian Queen!"

And this is what really happened
Four hundred years ago,
In fifteen thirty-one
As you rightly know."

—Silvino C. N. Martínez, 1954
*Corrido de las Apariciones de la Virgen de Guadalupe*

The Dark Virgin of Guadalupe,
painting by Carlos Trujillo,
private collection, MG.

*La Virgen Morena de Guadalupe,*
*pintura de Carlos Trujillo,*
*colección privada, MG.*

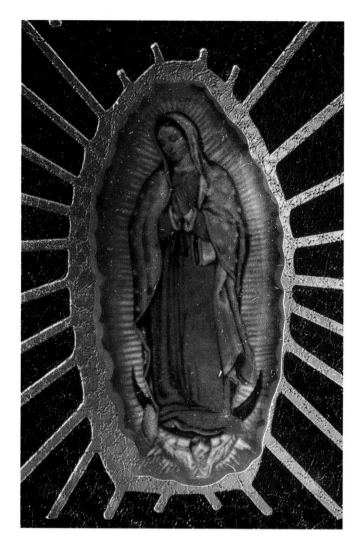

ABOVE:

The Virgin of Guadalupe, Spanish leather Bible cover, private collection, JL.

*La Virgen de Guadalupe, portada de piel en una Biblia de España, colección privada, JL.*

FACING:

The Virgin of Guadalupe, an electric Chinese clock, private collection, AS.

*La Virgen de Guadalupe, reloj electronico chino, colección privada, AS.*

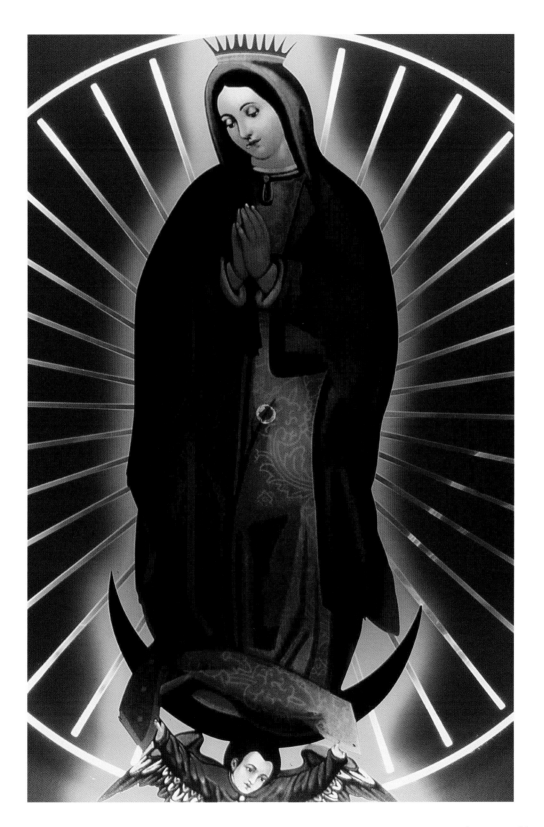

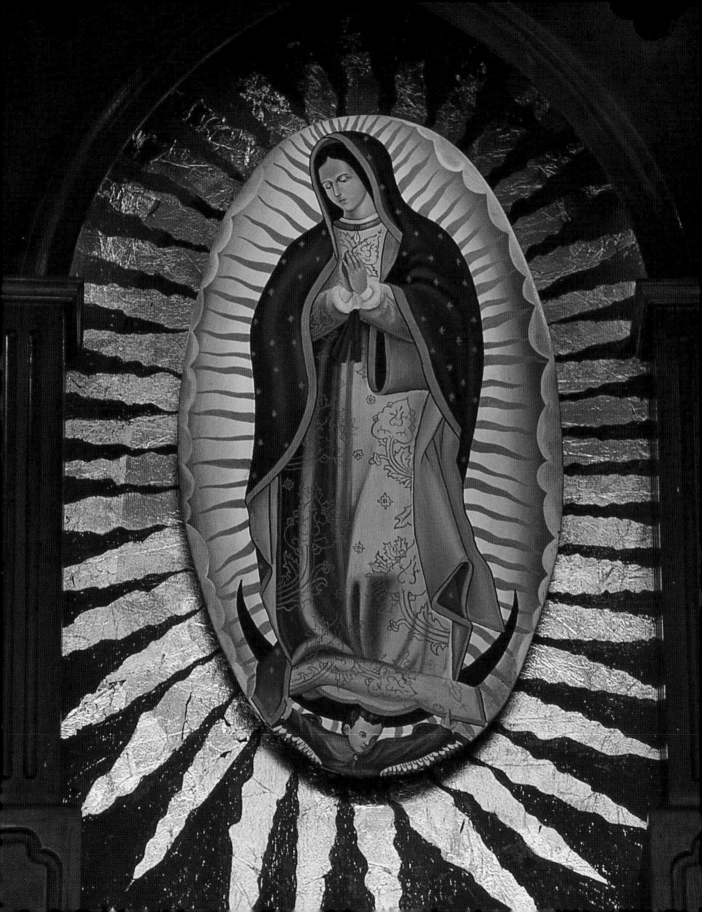

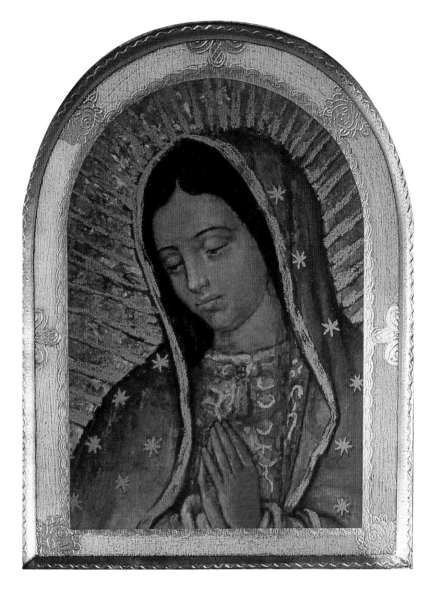

The Virgin of Guadalupe, in an Italian gold frame, private collection, JL.

*La Virgen de Guadalupe, en una marco dorado de Italia, colección privada, JL.*

The Virgin of Guadalupe, Manuel Doblado Central Market, Irapuato, Guanajuato, Mexico.

*La Virgen de Guadalupe, Mercado Central de Manuel Doblado, Irapuato, Guanajuato, México.*

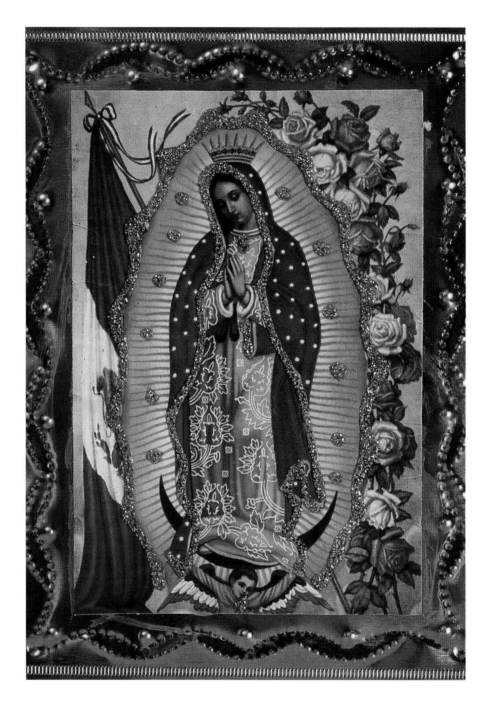

The Virgin of Mexico, hand-forged in a gold tin frame and dusted
with glitter, Guadalupe Avenue, Mexico City, Mexico.

*La Virgen de México, hecha a mano en marco dorado de arrempujado con
diamantina, Calzada de Guadalupe, México DF, México.*

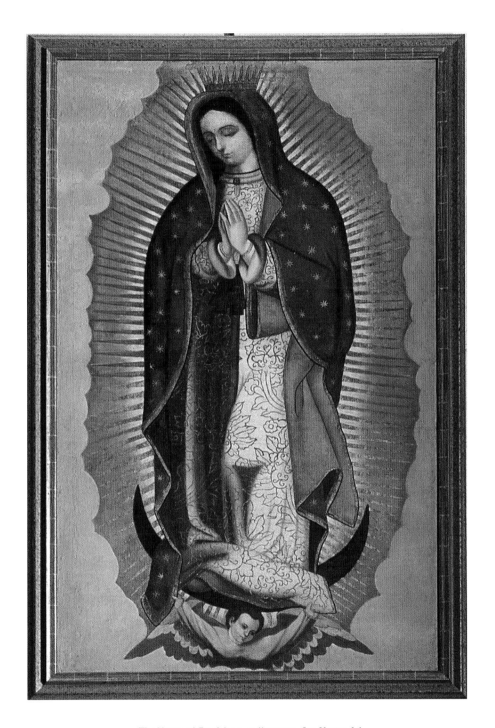

The Virgin of Guadalupe, wall picture, San Xavier del
Bac Mission, Tohono O'odham Nation, Arizona.

*La Virgen de Guadalupe, retrato en la pared, Misión San Xavier
del Bac, Wa:ak, Nación de los Tohono O'odham, Arizona.*

✠

# THE GREA✠ EVEN✠

*"By a great miracle appeared the heavenly queen,*
*Saint Mary, our precious mother of Guadalupe,*
*here near the great altepetl of Mexico,*
*at a place called Tepeyacac."*

—Luis Laso de la Vega, 1649
*Huei tlamahuiçoltica*, "The Great Event"

The Virgin of Guadalupe, flower
altar, Our Lady of Guadalupe
Basilica, Mexico City, Mexico.

*La Virgen de Guadalupe, altar de*
*flores, Basílica Nuestra Señora de*
*Guadalupe, México DF., México.*

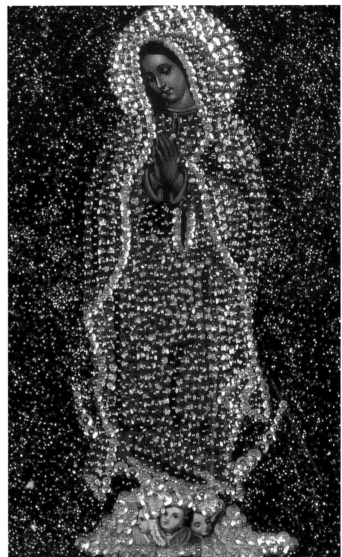

The Virgin of Guadalupe, stenciled on a burlap handbag, Guadalupe Avenue, Mexico City, Mexico.

*La Virgen de Guadalupe, pintada en bolsa de mano hecha de costal, Calzada de Guadalupe, México DF, México.*

ABOVE:
The Dark Virgin of Guadalupe, hand-stitched sequins on a black glitter background, Guanajuato, Mexico.

*La Virgen Morena de Guadalupe, lentejuela cosida a mano con diamantina en fondo negro, Guanajuato, México.*

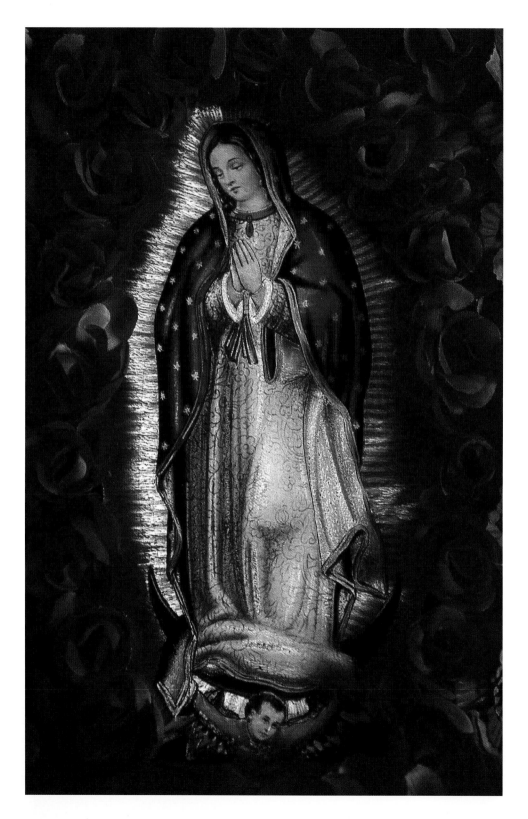

✠

# A SⰟNNE✠

*"Composed of flowers of wonder,*
*Divine American protector,*
*that to being a Mexican rose,*
*Appearing as a Castilian rose."*

—Sor Juana Inés de la Cruz, 1682
"Poetic Praise to the Father Francisco de Castro"

The Virgin of Guadalupe, a red flower
arrangement, the "Old House,"
Arizona.

*La Virgen de Guadalupe, con arreglo floral*
*rojo, La Casa Vieja, Arizona.*

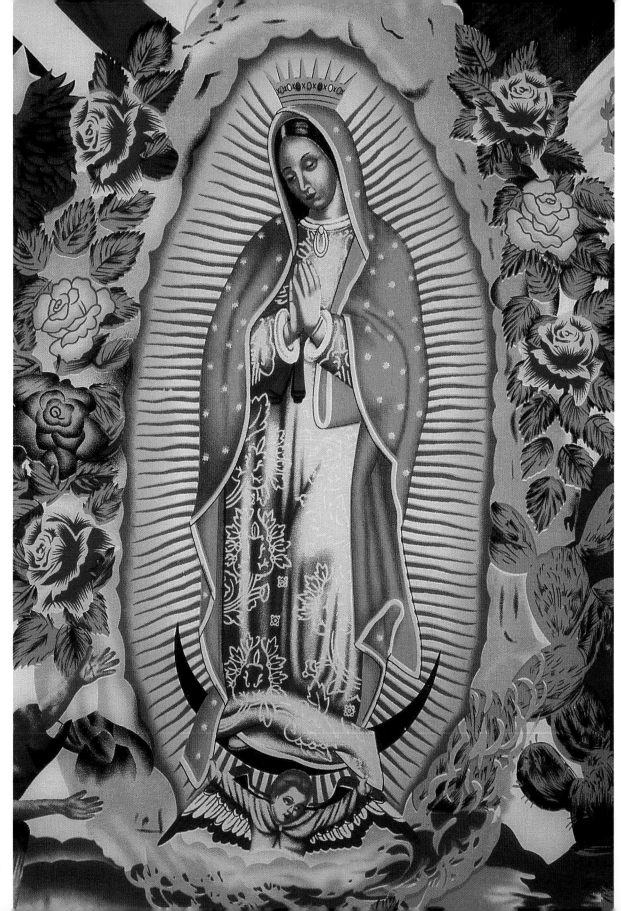

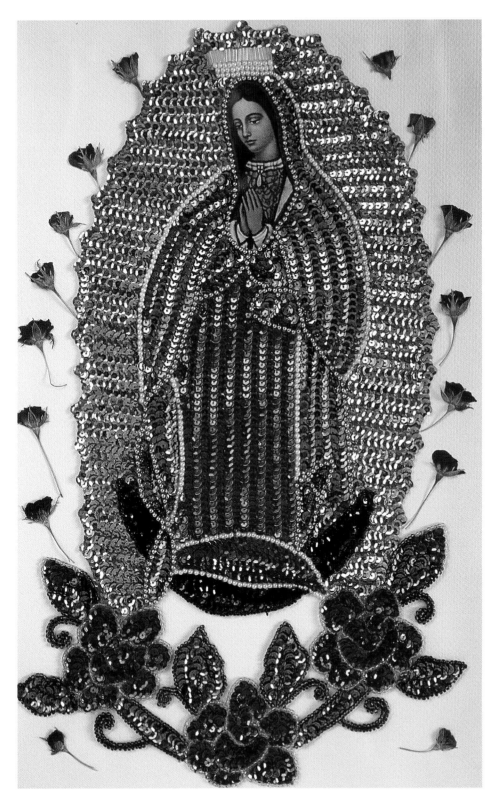

FACING:
The Virgin of Guadalupe,
bandana made in China,
Los Angeles, California.

*La Virgen de Guadalupe,*
*bandana hecha en China,*
*Los Angeles, California.*

LEFT:
The Virgin of Guadalupe,
hand-stitched sequins
and dry flowers, Irapuato,
Guanajuato, Mexico.

*La Virgen de Guadalupe,*
*lentejuela cosida a mano*
*con flores secas, Irapuato,*
*Guanajuato, México*

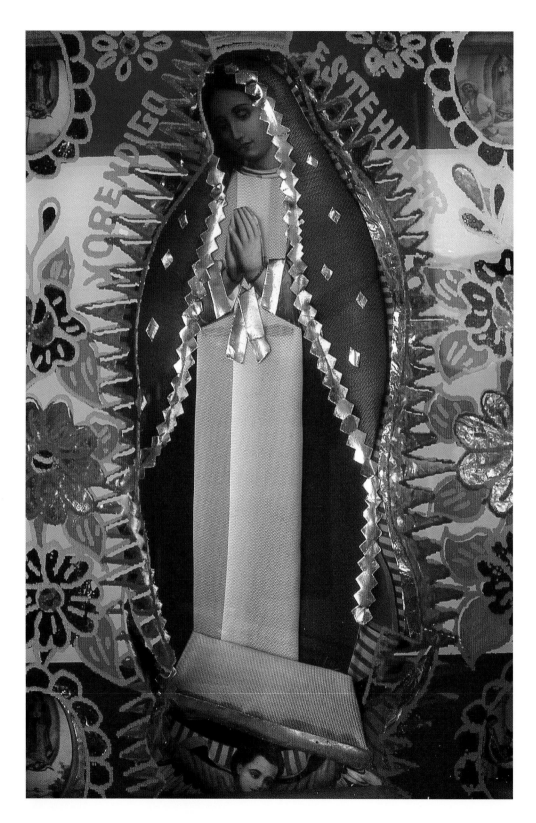

✠

# A Last Will and Testament

"Through this young man [Juan Diego], something prodigious occurred there in Tepeyácac. To him the Beautiful Lady, Our Holy Mary uncovered Herself or appeared. Her image we saw there in Guadalupe which belongs to us, those of this city of Cuautitlán. Now, with all my soul, with all my heart and with all my will I leave to the same Lady all the grove of Pirú which goes as far as the tree next to the group of houses. I leave it all and I turn it over to the Virgin of Tepeyácac. I also warn the house, or hut in which I find myself I leave to all my children, and grandchildren if they were to have them, so that they will have something settled and will serve the Beautiful Lady."

—Juana Martín, March 11, 1559
*Testamento de la Hija de Juan García Martín*

The Virgin of Guadalupe,
glass-covered with gold trim,
private collection, MG.

*La Virgen de Guadalupe, en
vitrina con realces dorados,
colección privada, MG.*

The Virgin of Guadalupe, altar cloth shield,
St. Monica's Church, Tucson, Arizona.

*La Virgen de Guadalupe, escudo en el mantel del
altar, Iglesia de Santa Monica, Tucson, Arizona.*

The Virgin of Guadalupe, a
cloth table runner, private
collection, AMA.

*La Virgen de Guadalupe, mantel de
mesa, colección privada, AMA.*

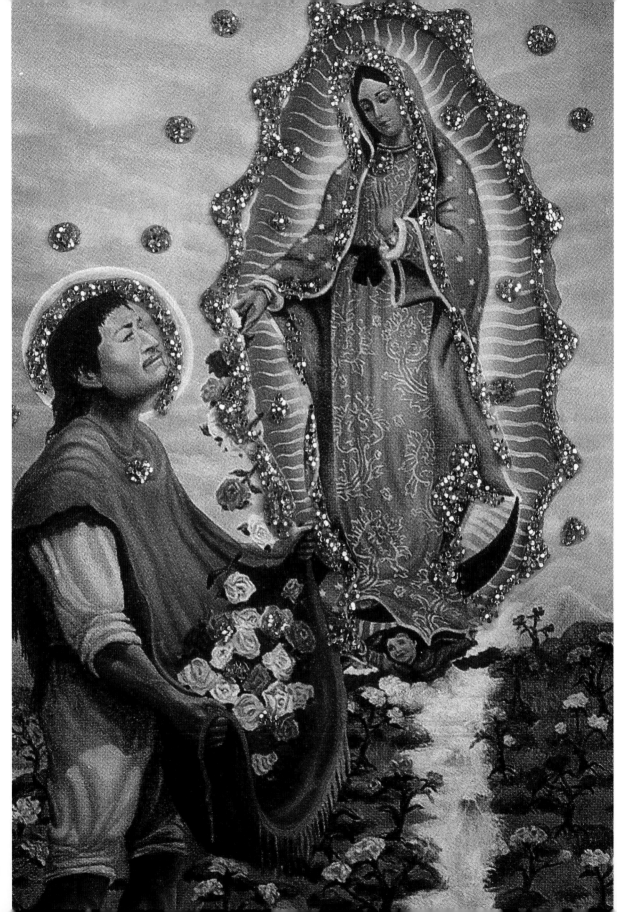

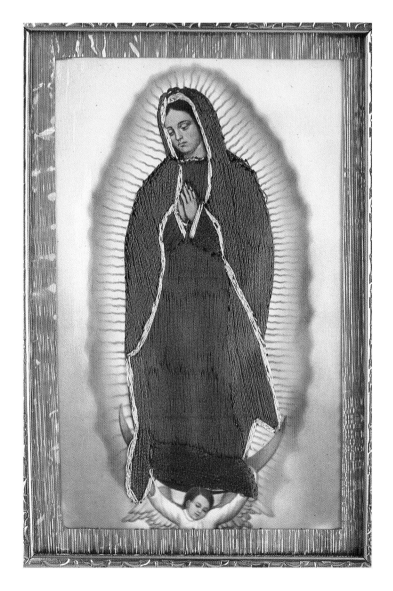

FACING:
The Virgin of Guadalupe and Juan Diego, color picture highlighted
with glitter, Guadalupe Avenue, Mexico City, Mexico.

*La Virgen de Guadalupe y Juan Diego, retrato de color con diamantina,
Calzada de Guadalupe, México DF, México.*

ABOVE:
The Virgin of Guadalupe, a hand-sewn postcard from Spain,
private collection, MG.

*La Virgen de Guadalupe, postal de España bordada a mano,
colección privada, MG.*

✠

# Juan Diego and the First Apparition of the Virgin of Guadalupe

"Her perfect grandeur exceeded all imagination: her clothing was shining like the sun, as if it were sending out waves of light, and the stone, the crag on which she stood, seemed to be giving out rays; her radiance was like precious stones, it seemed like an exquisite bracelet [it seemed beautiful beyond anything else]; the earth seemed to shine with the brilliance of a rainbow in the mist."

—Antonio Valeriano, 1556
*Nicān Mopōhua*, "Here It Is Told"

The Virgin of Guadalupe and Juan Diego, picture with a miracle offering, private collection, AS.

*La Virgen de Guadalupe y Juan Diego, retrato con una ofrenda de milagro, colección privada, AS.*

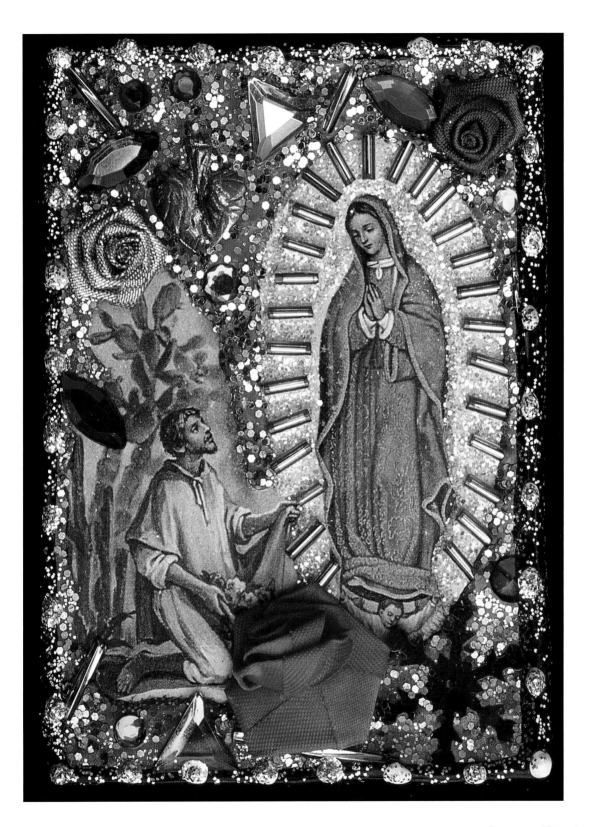

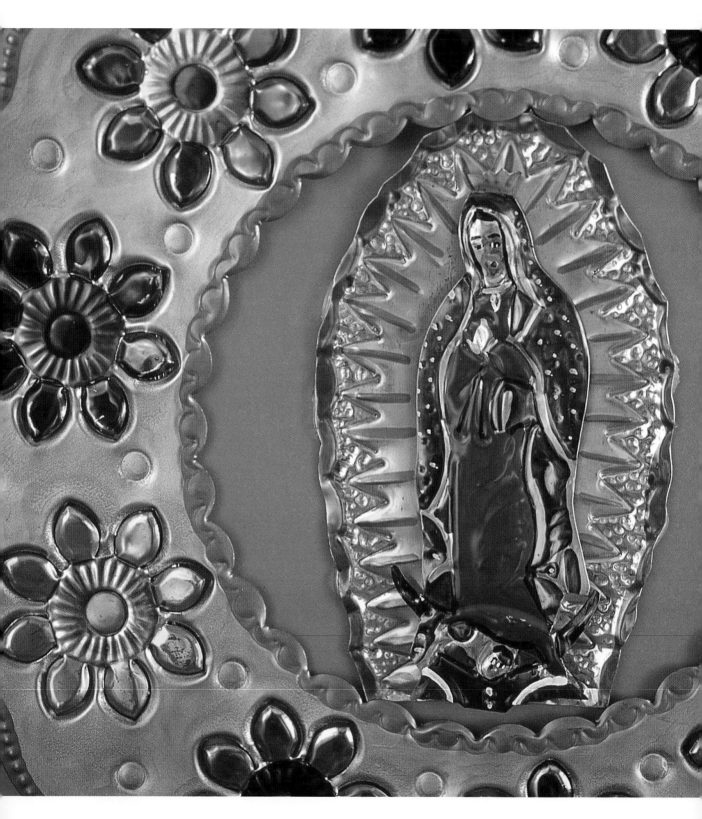

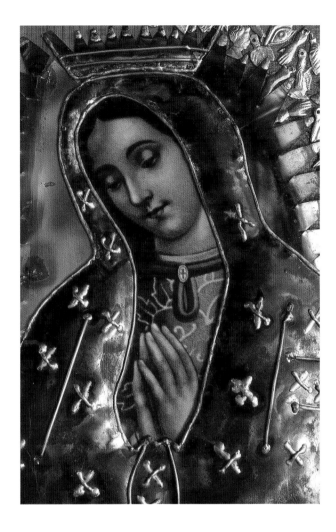

The Virgin of Guadalupe, a hand-forged,
painted tin crown, private collection, AS.

*La Virgen de Guadalupe, hecha a mano en arrempujado
en corona de hojalata, colección privada, AS.*

The Virgin of Guadalupe, hand sculpted and bronzed
with miracle offerings, private collection, JL.

*La Virgen de Guadalupe, hecha a mano en hojalata
con ofrendas de milagros, colección privada, JL.*

ABOVE:
The Virgin of Guadalupe, in a hand-forged tin frame, private collection, AS.

*La Virgen de Guadalupe, hecha a mano en arrempujado en*
*marco de hojalata, colección privada, AS.*

FACING:
The Virgin of Guadalupe, hand made in copper, private collection, AMA.

*La Virgen de Guadalupe, hecha a mano en cobre, colección privada, AMA.*

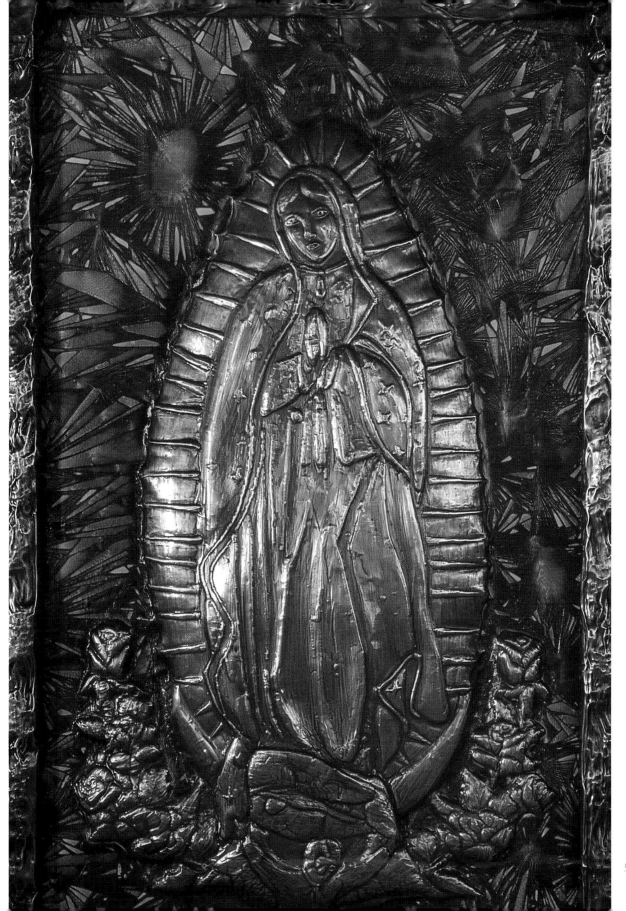

The Virgin of Guadalupe,
glass-window tin altar, the Old
Pueblo of Tucson, Arizona.

*La Virgen de Guadalupe, altar en
un nicho de vidrio y arrempujado,
el Pueblo Viejo de Tucson, Arizona.*

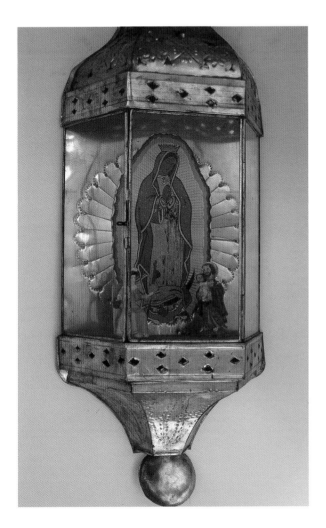

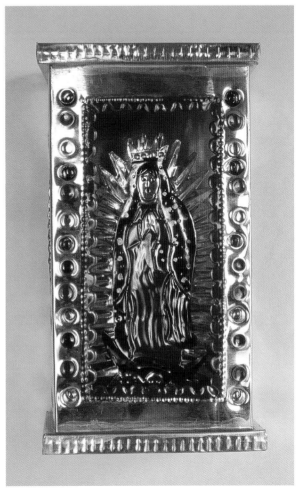

The Virgin of Guadalupe, an aged tin altar,
the Old Pueblo of Tucson, Arizona.

*La Virgen de Guadalupe, altar en un nicho antiguo de
arrempujado, El Pueblo Viejo de Tucson, Arizona.*

The Virgin of Guadalupe, hand-forged tin altar,
the Old Pueblo of Tucson, Arizona.

*La Virgen de Guadalupe, altar en un nicho de arrempujado
hecho a mano, El Pueblo Viejo de Tucson, Arizona.*

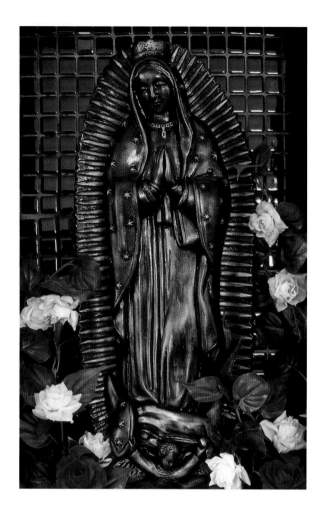

The Virgin of Guadalupe, video store
tile shrine, Menlo Park, Arizona.

*La Virgen de Guadalupe, capillita de azulejo
de la tienda de videos, Menlo Park, Arizona.*

The Virgin of Guadalupe, handmade
tile street picture, the Old
Pueblo of Tucson, Arizona.

*La Virgen de Guadalupe, retrato en
la calle hecho de azulejo, el Pueblo
Viejo de Tucson, Arizona.*

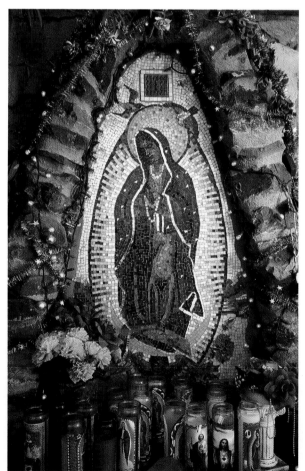

The Virgin of Guadalupe, a
mosaic image in a stone shrine,
"A" Mountain, Arizona.

*La Virgen de Guadalupe, capilla
de piedras con imagen de mosaico,
Cerro de la "A," Arizona.*

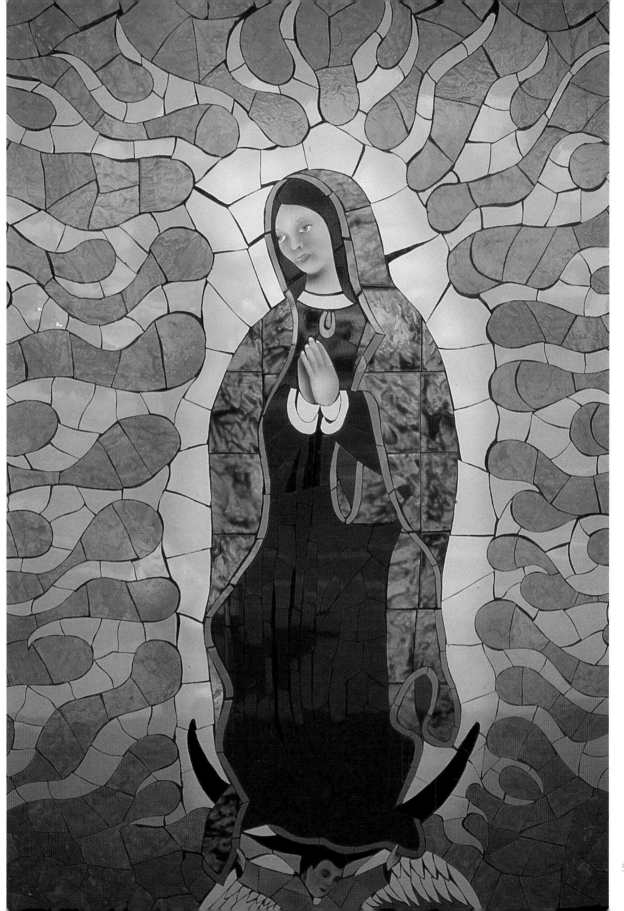

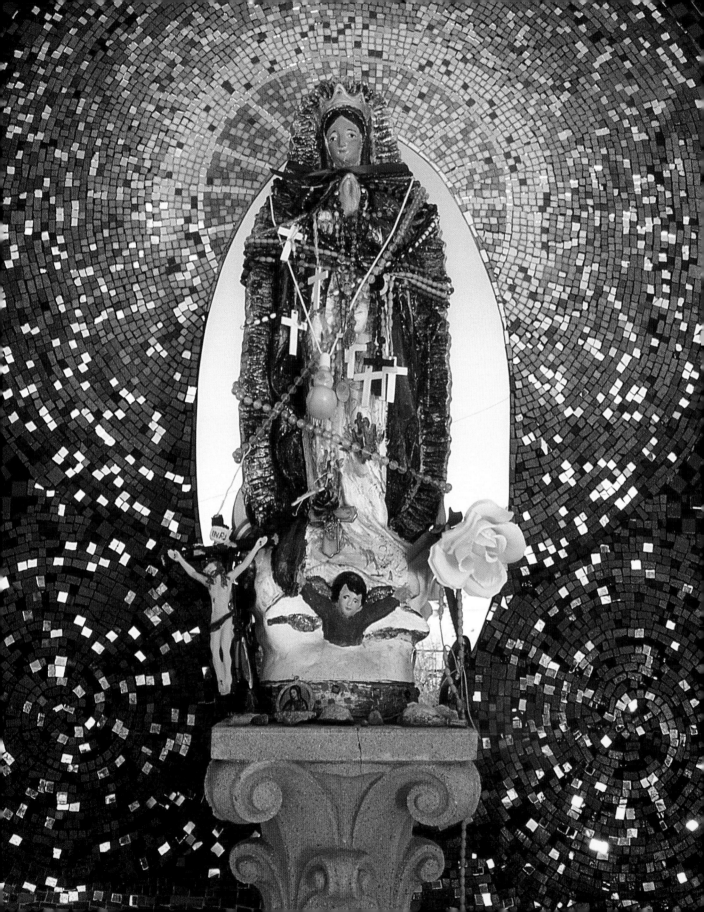

✠

# A Mystical Apparition

"A beautiful white woman dressed in white, gray, and blue, covered with a veil from head to foot, had come to these lands. She [The Lady in Blue] spoke to them and shouted and chided them in an unknown language. She carried a cross. They said the nations of the Colorado River shot her twice, leaving her for dead, and that returning to life she would fly away without their knowing where her home was. After a few days she would return."

—Juan Mateo Manje, 1699

*Luz de Tierra Incognita*

The Virgin of Guadalupe, tile
and cut-glass mosaic altar,
Tumamoc Hill, Arizona.

*La Virgen de Guadalupe, altar
de mosaico y pedazos de espejo,
Cerro de Tumamoc, Arizona.*

FACING:

The Virgin of Guadalupe, a tile image set
in an adobe wall, Santa Cruz Parochial
Church, the Old Pueblo of Tucson, Arizona.

*La Virgen de Guadalupe, imagen en azulejo
colocada en pared de adobe, Parroquía de
Santa Cruz, El Pueblo Viejo, Arizona.*

ABOVE:

The Virgin of Guadalupe, a tile picture set
in an adobe wall, private collection, MG.

*La Virgen de Guadalupe, imagen
de azulejo colocada en pared de
adobe, colección privada, MG.*

RIGHT:

The Virgin of Guadalupe, tile image set in
an adobe wall, San Xavier del Bac Mission,
Tohono O'odham Nation, Arizona.

*La Virgen de Guadalupe, imagen en
azulejo colocada en pared de adobe,
Misión San Xavier del Bac, Wa:ak, Nación
de los Tohono O'odham, Arizona.*

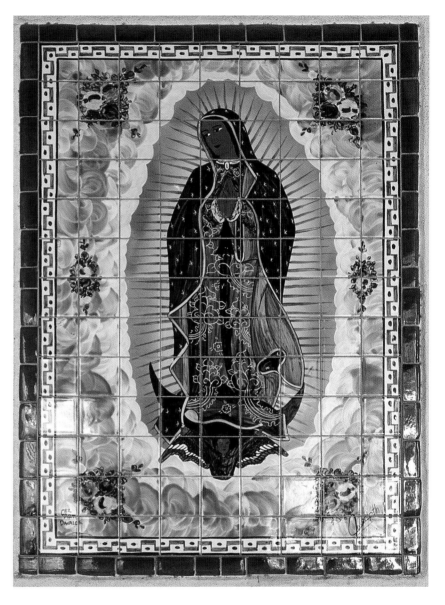

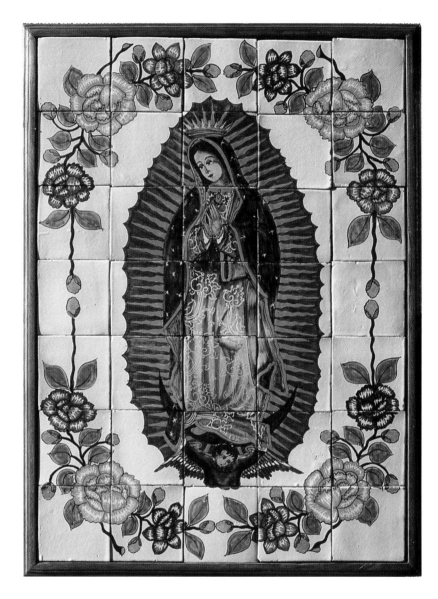

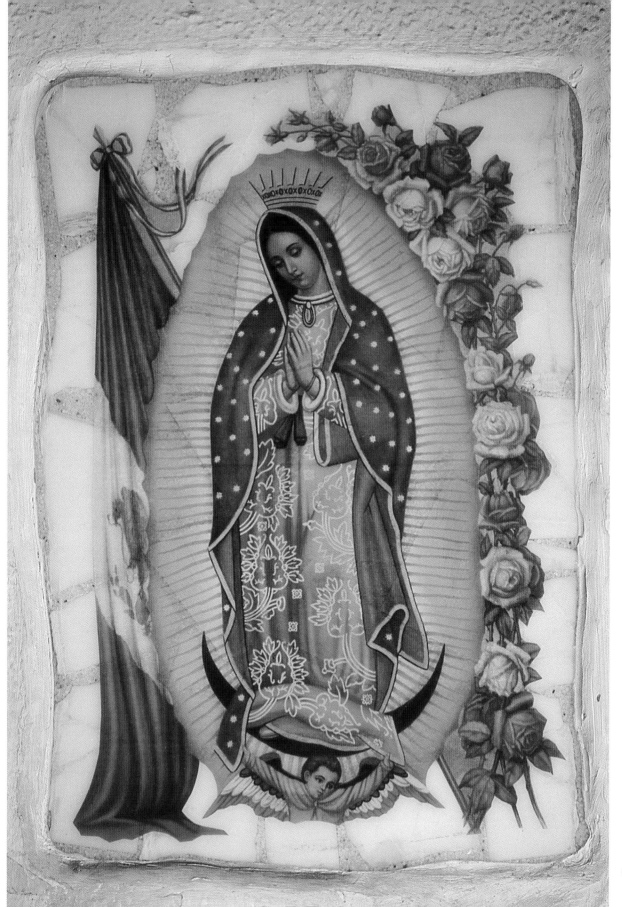

# AN OBSERVATION

*"The wooden Virgin was a sorrowing mother indeed,
long and stiff and severe . . ."*

—Willa Cather, 1927

*Death Comes for the Archbishop*

The Virgin of Guadalupe, New
Mexico–style hand-carved wooden
sculpture, Tubac, Arizona.

*La Virgen de Guadalupe, escultura
de madera tallada a mano estilo de
Nuevo México, Tubac, Arizona.*

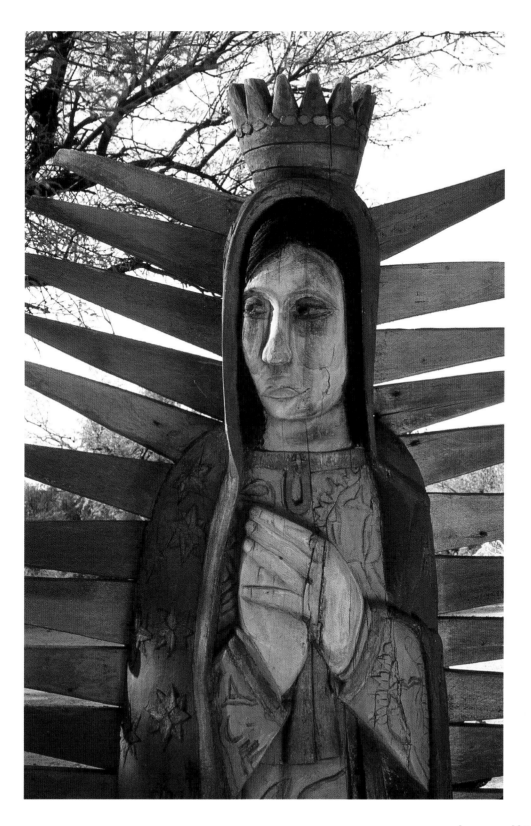

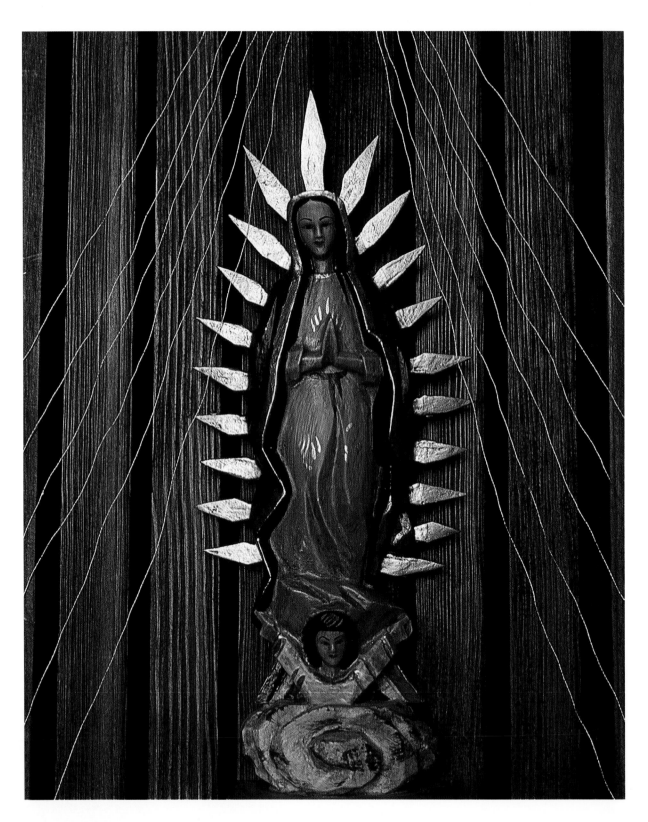

The Virgin of Guadalupe, a varnished wooden painting from El Salvador, private collection, MG.

*La Virgen de Guadalupe, pintura en madera varnisada de El Salvador, colección privada, MG.*

The Virgin of Guadalupe painted hand-carved wooden statue, private collection, AS.

*La Virgen de Guadalupe escultura de madera tallada y pintada a mano, colección privada, AS.*

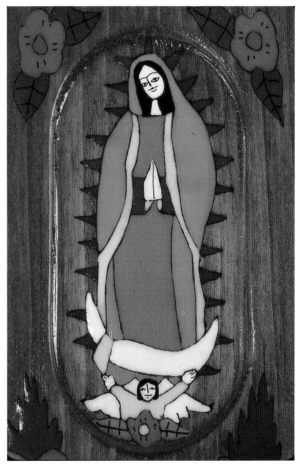

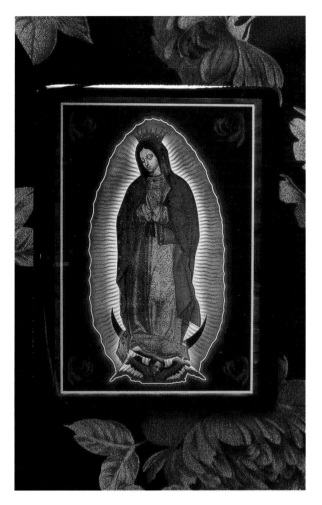

The Virgin of Guadalupe, in laminated wood over flowered cloth, private collection, MG.

*La Virgen de Guadalupe, madera laminada sobre tela de flores, colección privada, MG.*

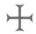

# A Translation

"The origin of this shrine to Tonantzin is not known for sure, but what we truly know is the significance of the word, from its original reference to that ancient Tonantzin, and this is something that should be remedied, because the true name of the Mother of God, Our Lady, is not Tonantzin, "Mother of us all," but God and nantzin, "Mother of God.""

—Fray Bernardino de Sahagún, 1570
*Historia de las Cosas de Nueva España*

The Virgin of Guadalupe, shrine of a lost wooden antique discovered between house walls, Tumamoc Hill, Arizona.

*La Virgen de Guadalupe, capillita hecha para la antigua virgen encontrada entre las paredes de una casa, Cerro Tumamoc, Arizona.*

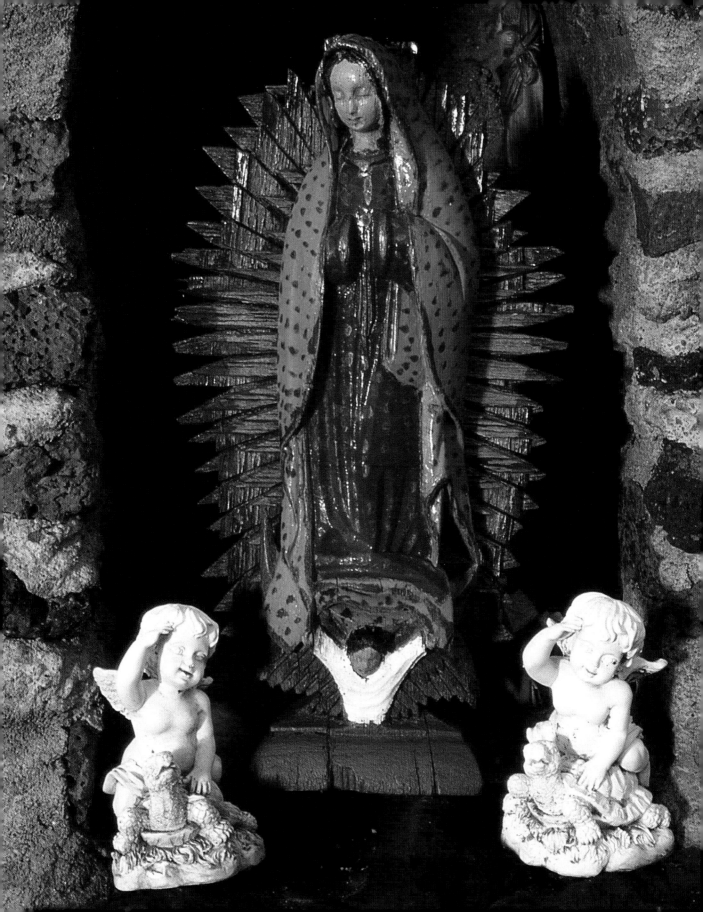

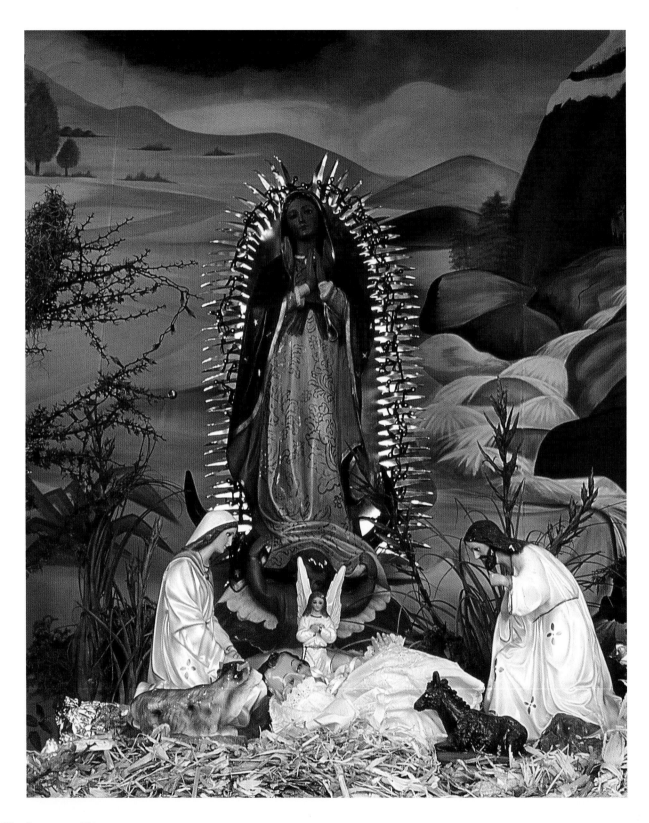

✠

# THE WORLD'S SALVATION

*"Mother of Life, of Beauty, Majesty*
*Star of our morning, shining on our sea,*
*Mystical Heaven, bearing Divinity*
*Sun-clothed and Sun-begetting—see.*
*Wonder of wonders. Mother of God is she."*

—Emily Mary Shapcote, 1904
*Mary: The Perfect Woman*

The Virgin of Guadalupe, central
plaza nativity scene, San Miguel
de Allende, Guanajuato, Mexico.

*La Virgen de Guadalupe, Nacimiento*
*Navideño en la plaza central, San Miguel*
*de Allende, Guanajuato, México.*

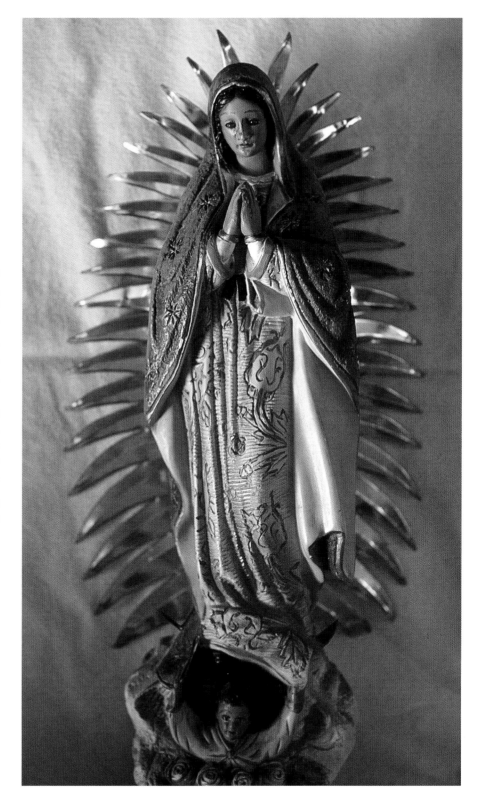

✠

# A Recounting

"Her name [Tonantzin] signifies 'Our Mother', and I do not doubt that she was the same as the goddess *Centeotl*, of whom I have already told. Tonantzin had a temple on a hill one league north of Mexico City, and her feasts were attended by an immense concourse of people and many sacrifices."

—Francesco Saverio Clavijero, 1787
*La Historia Antigua de México*

The Virgin of Guadalupe, flower altar, Our Lady of Guadalupe Basilica, Mexico City, Mexico.

*La Virgen de Guadalupe, altar de flores, Basílica Nuestra Señora de Guadalupe, México DF., México*

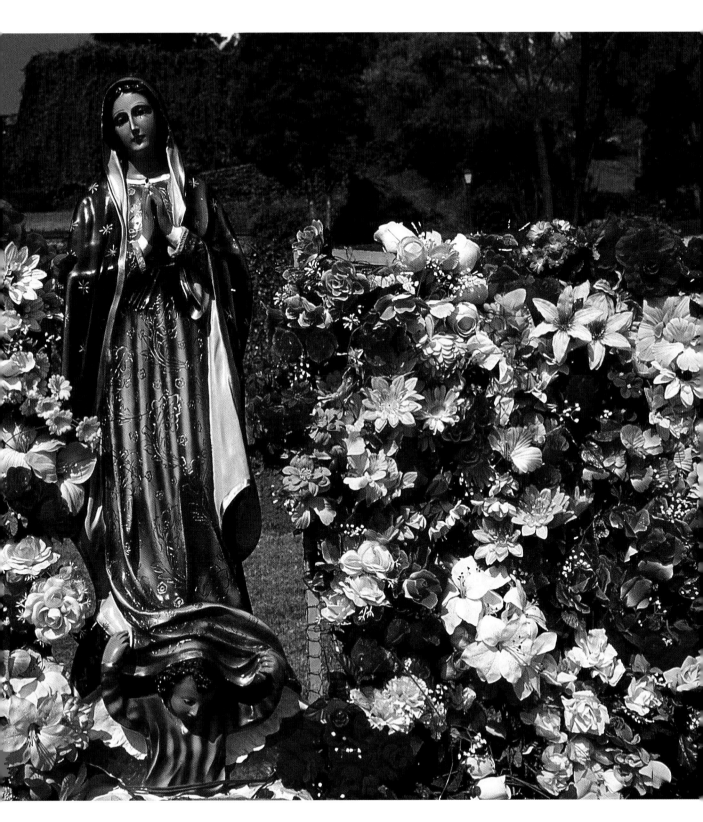

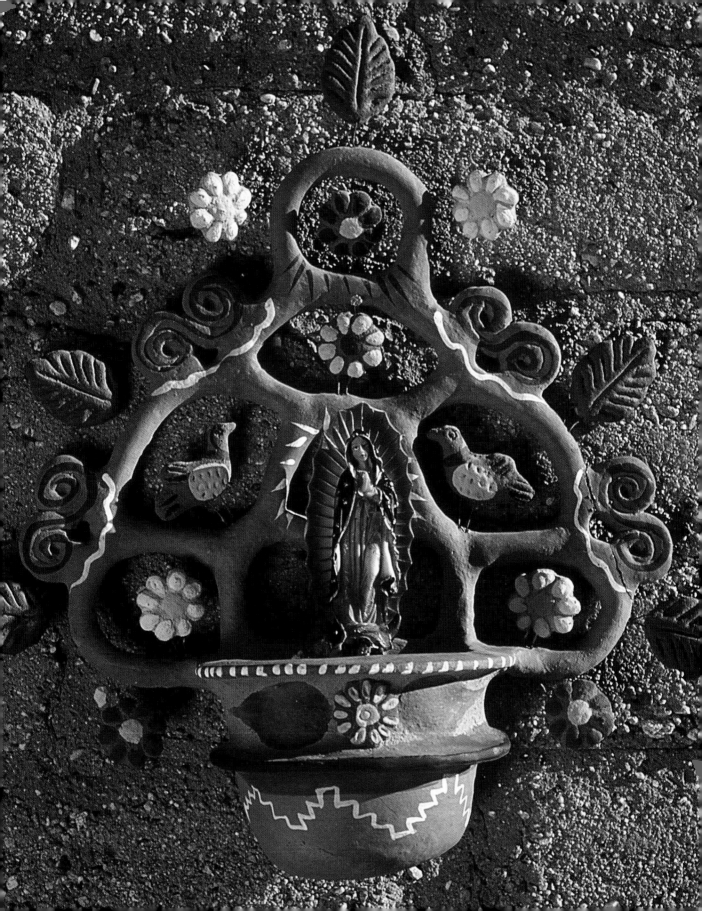

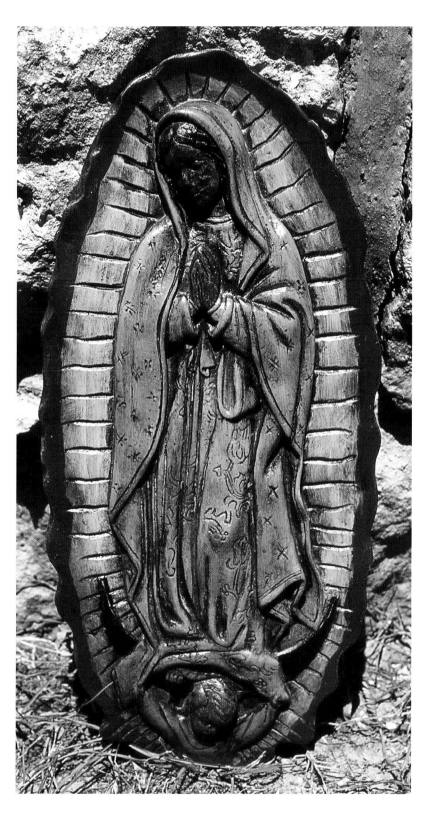

FACING:
The Virgin of Guadalupe, hand-painted clay statue, Chichen Itza, Yucatan, Mexico.

*La Virgen de Guadalupe, estatua de barro pintada a mano, Chichén Itzá, Yucatán, México.*

LEFT:
The Virgin of Guadalupe, a handmade Mexican clay flower pot, the Old Pueblo of Tucson, Arizona.

*La Virgen de Guadalupe, macetero hecho a mano en Mexico, el Pueblo Viejo de Tucson, Arizona.*

ABOVE:
The Virgin of Guadalupe, painted bust, private collection, AMA.

*La Virgen de Guadalupe, busto pintado, colección privada, AMA.*

✠

# A Southwest Legend

"He was exceedingly tired and sore of foot, and was in such

a state that he was prepared to die. Then he saw before him

the Blue Lady, beckoning him on. He stumbled along after

her, and after awhile she stopped. When he came up he saw,

beside her, a spring of fresh water, and he fell on his breast

and drank his fill . . ."

—Cleve Hallenbeck, 1938
*Legends of the Spanish Southwest*

The Virgin of Guadalupe,
turquoise-and-gold-painted
plaster, private collection, AMA.

*La Virgen de Guadalupe, yeso pintado
en color azul turquesa con rayitos
dorados, colección privada,* AMA.

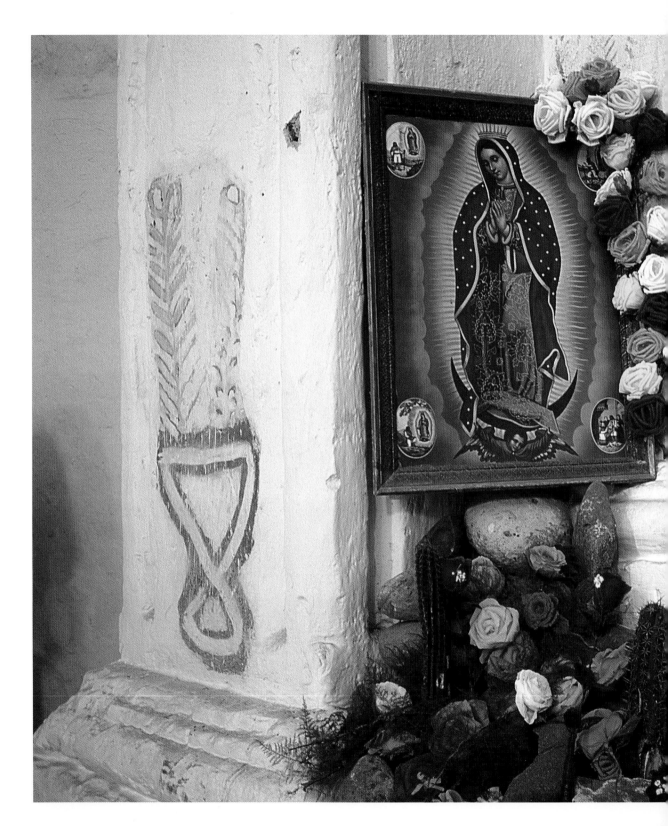

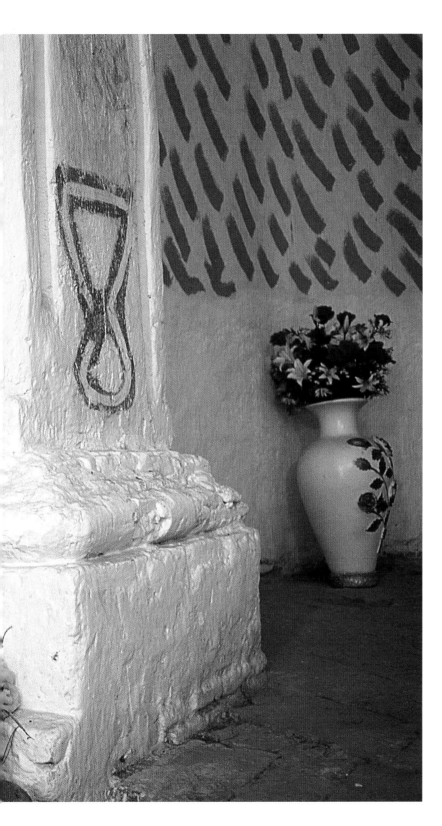

The Virgin of Guadalupe, altar, Saint
Arcangel de Guadalupe of Satevo
Mission, Chihuahua, Mexico.

*La Virgen de Guadalupe, altar, Misión
de Santo Arcángel de La Guadalupe
de Satevó, Chihuahua, México.*

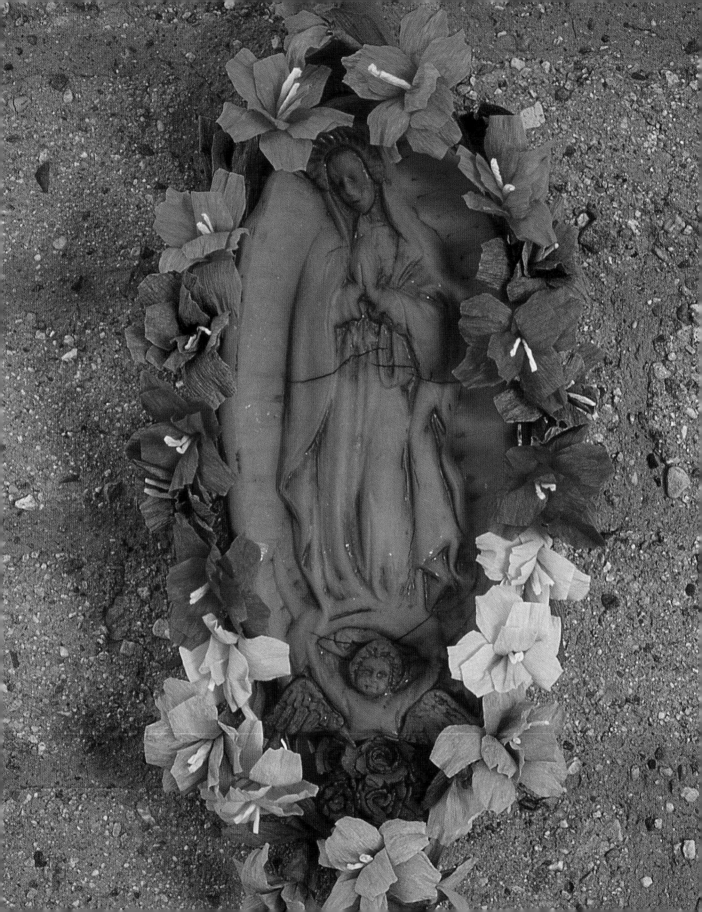

✛

# AN AZTEC SONG

*"Painted by the flowering ear of corn my heart comes to life.*
*Now the various flowers of our sustenance are scattered about,*
*bursting into bloom in the divine presence of our mother, Holy Mary.*
*Your heart is alive in your painting.*
*And we, the lords of this land,*
*sing all together from the book of songs.*
*In perfect harmony we dance before you."*

—Cantares Mexicanos, circa 1550–80

*Teponazcuicatl,* Náhuatl, "The Procession of the Drum"

The Virgin of Guadalupe, clay bust
adorned with handmade corn husk
flowers, private collection, AS.

*La Virgen de Guadalupe de barro*
*adornada con flores hechas a mano de*
*hoja de maíz, colección privada, AS.*

✝

## AN OBSERVATION

"Clearly here is something which has captured the emotions and souls of the people . . . Nothing to be seen in Canada or Europe equals it in the volume or the vitality of its moving quality or in the depth of its spirit of religious devotion."

—F. S. C. Northrop, 1946
*The Meeting of East and West*

The Virgin of Guadalupe, Juan and Juanita Telles Grotto Shrine, John Ward Ranch, Highway 82, Patagonia, Arizona.

*La Virgen de Guadalupe, capilla en la gruta de Juan y Juanita Telles, Rancho de John Ward, Carretera 82, Patagonia, Arizona.*

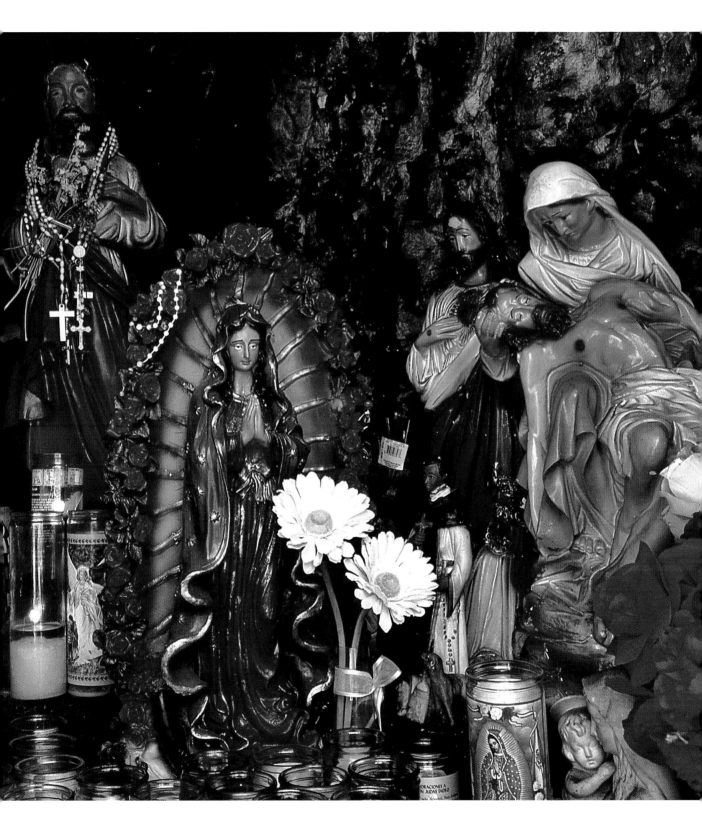

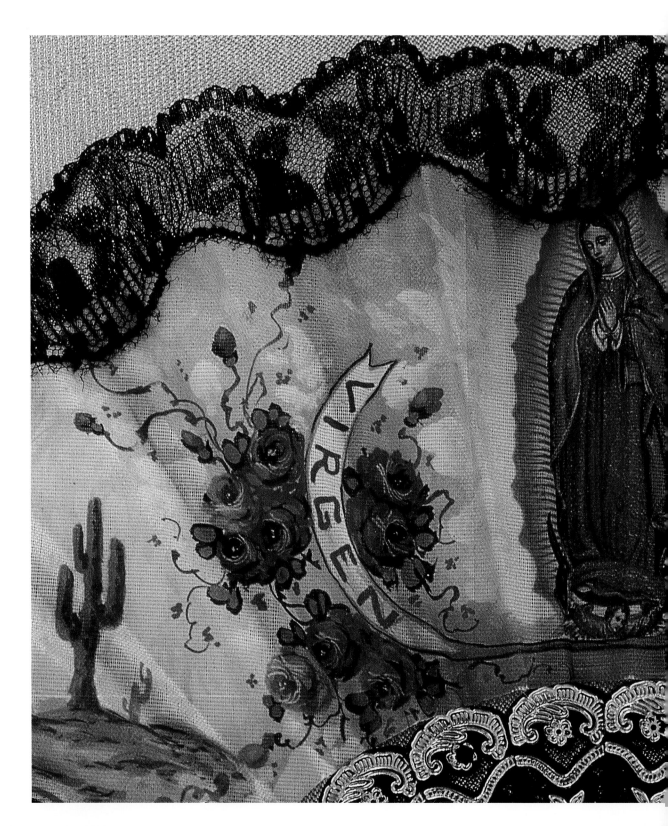

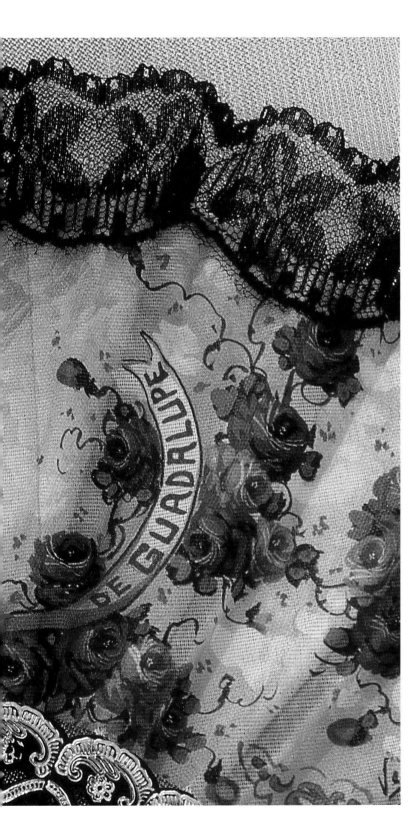

The Virgin of Guadalupe, hand-painted
Spanish fan, private collection, JL.

*La Virgen de Guadalupe, abanico pintado a
mano de España, colección privada, JL.*

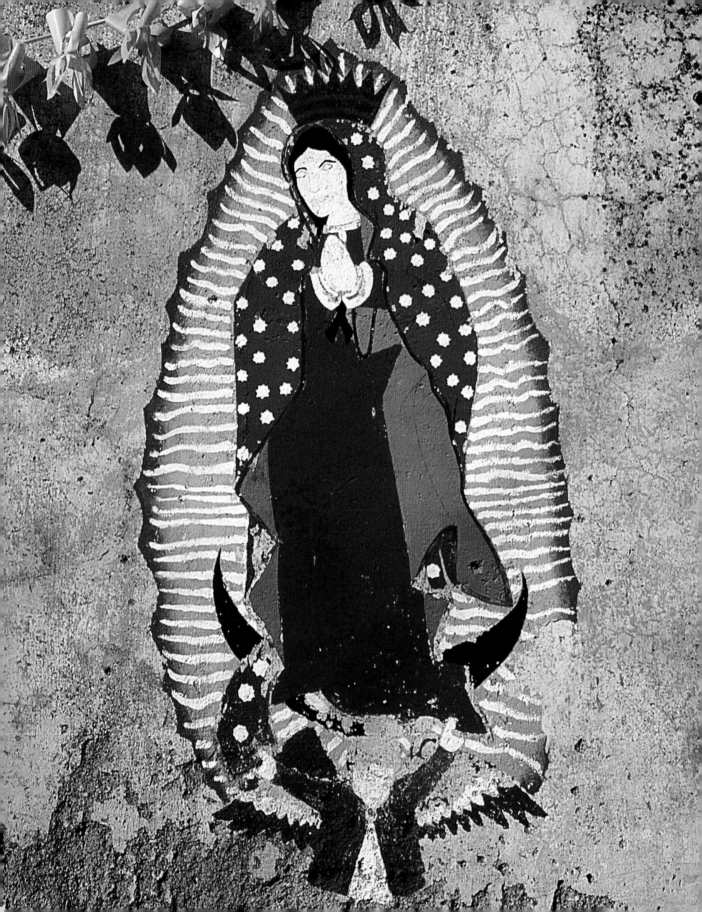

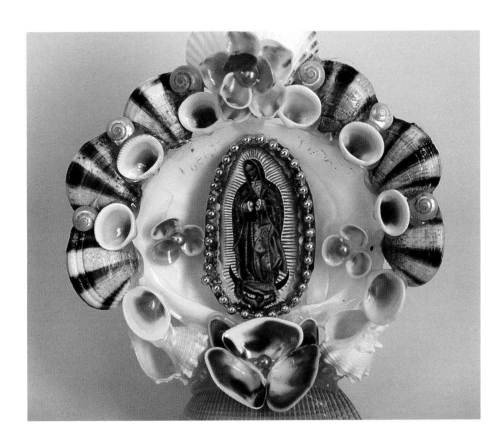

Facing:

The Virgin of Guadalupe, Manuel Aleman Street mural,
Rancho La Aldea, Guanajuato, Mexico.

*La Virgen de Guadalupe, mural en la Calle Manuel Alemán,
Rancho La Aldea, Guanajuato, México.*

Above:

The Virgin of Guadalupe, handmade sea shell shrine,
Puerto Penasco, Sonora, Mexico.

*La Virgen de Guadalupe, altar hecho a mano dentro de una concha
de mar, Puerto Peñasco, Sonora, México.*

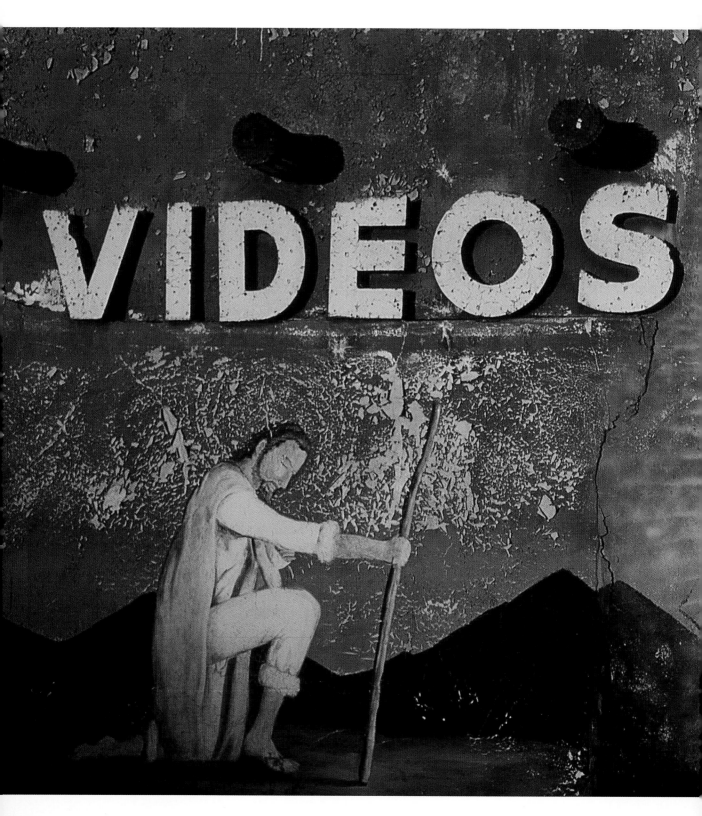

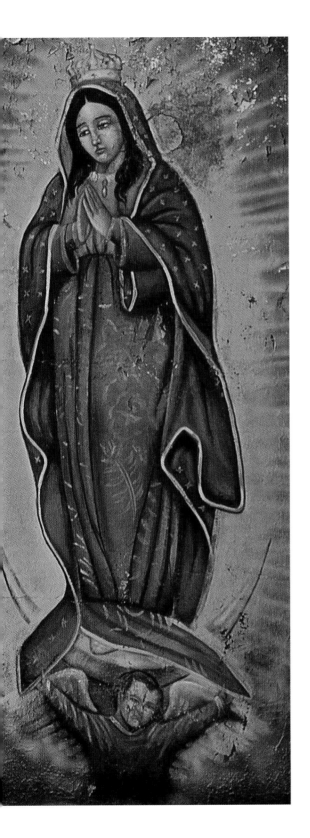

# Juan Diego and the First Apparition of the Virgin of Guadalupe

"He prostrated himself in her presence. He listened to her voice [her breath], her words, which give great, great glory, which were extremely kind, as if she were drawing him toward her and esteemed him highly."

—Antonio Valeriano, 1556

*Nicān Mopōhua,* "Here It Is Told"

The Virgin of Guadalupe and Juan Diego, (Saint Juan Diego Cuahtlatoatzin), video store mural by Miguel Ángel Grijalva, Menlo Park, Arizona, private collection, MG.

*La Virgen de Guadalupe y Juan Diego, (Santo Juan Diego Cuahtlatoatzin), mural de tienda de videos, por Miguel Ángel Grijalva, Menlo Park, Arizona, colección privada, MG.*

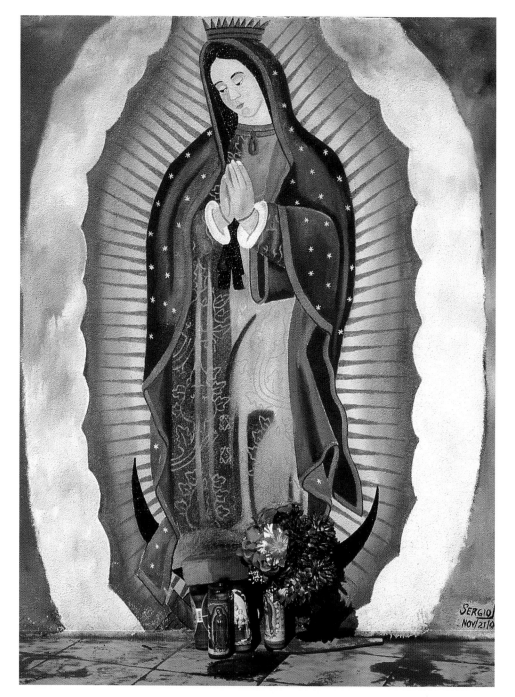

RIGHT:
The Virgin of Guadalupe,
Highway 15 mural, Penasco
Hill, Sonora, Mexico.

*La Virgen de Guadalupe,
mural en la Carretera
15, Cerro de Peñasco,
Sonora, México.*

FACING:
The Virgin of Mexico,
Highway 15 mural, Penasco
Hill, Sonora, Mexico.

*La Virgen de México, mural
en la Carretera 15, Cerro de
Peñasco, Sonora, México.*

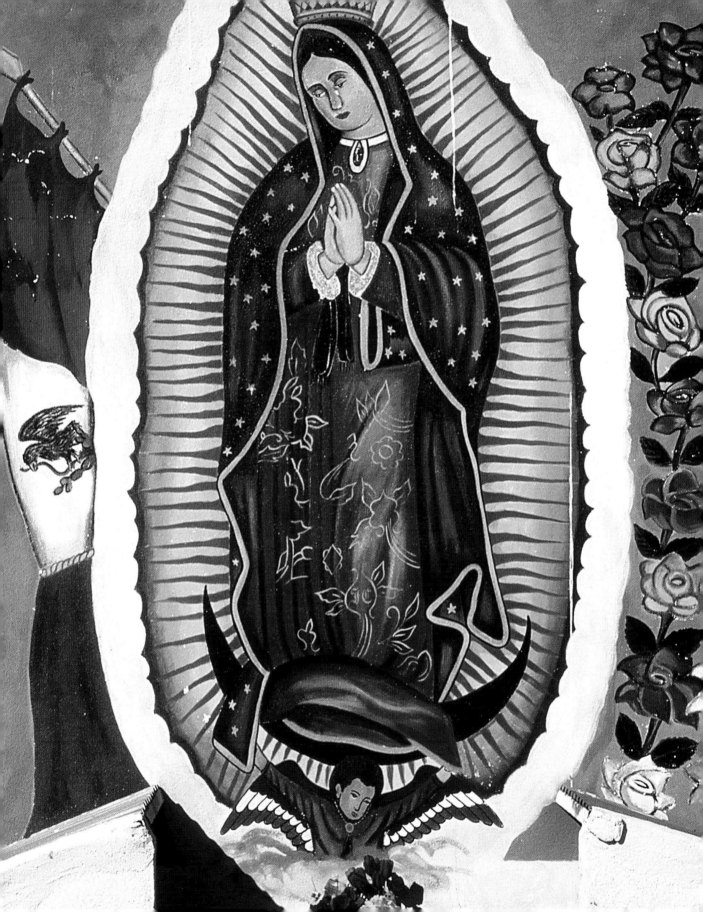

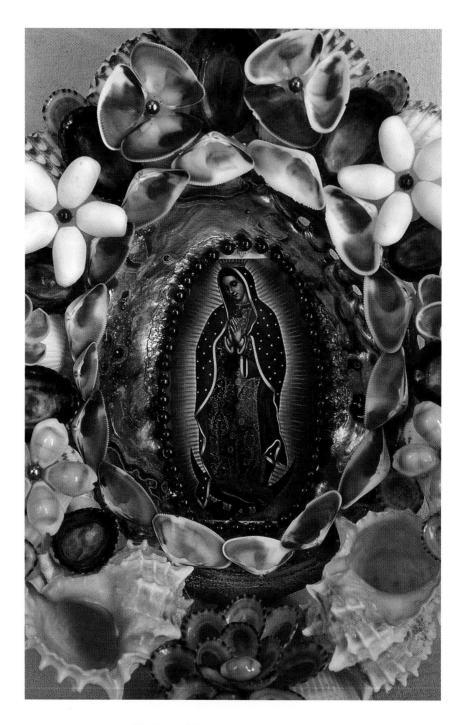

The Virgin of Guadalupe, a handmade sea shell
shrine, Puerto Penasco, Sonora, Mexico.

*La Virgen de Guadalupe, altar hecho a mano dentro de
una concha de mar, Puerto Peñasco, Sonora, México.*

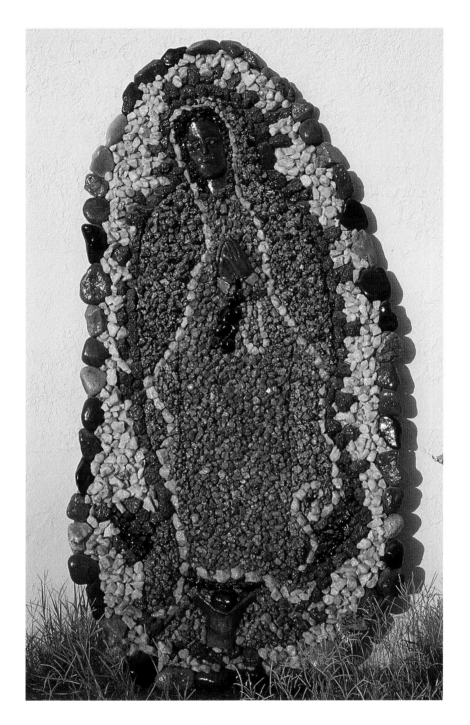

The Virgin of Guadalupe, a handmade stone
and resin sculpture, private collection, MG.

*La Virgen de Guadalupe, escultura de resina hecha
a mano con piedras, colección privada, MG.*

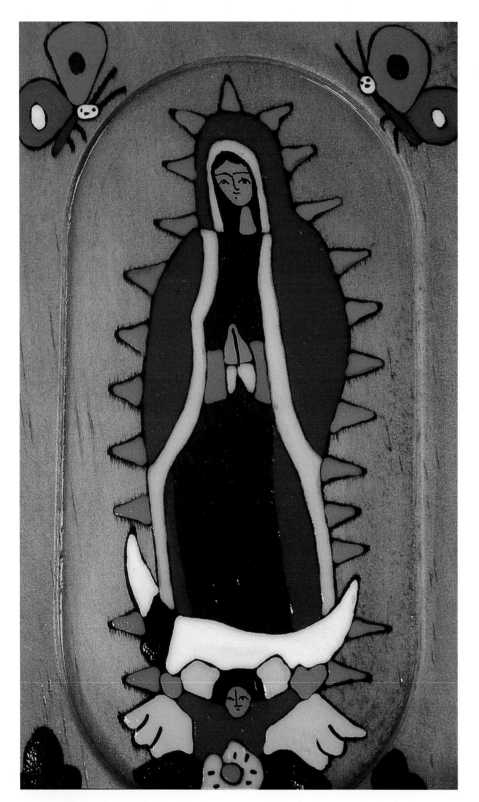

LEFT:
The Virgin of Guadalupe, a
varnished wooden painting
from El Salvador, private
collection, MG.

*La Virgen de Guadalupe, pintura*
*en madera varnisada de El*
*Salvador, colección privada, MG.*

FACING:
The Virgin of Guadalupe, a
laminated wooden painting of
an El Salvador country scene,
private collection, MG.

*La Virgen de Guadalupe, pintura en*
*madera varnisada con un paisaje de*
*El Salvador, colección privada, MG.*

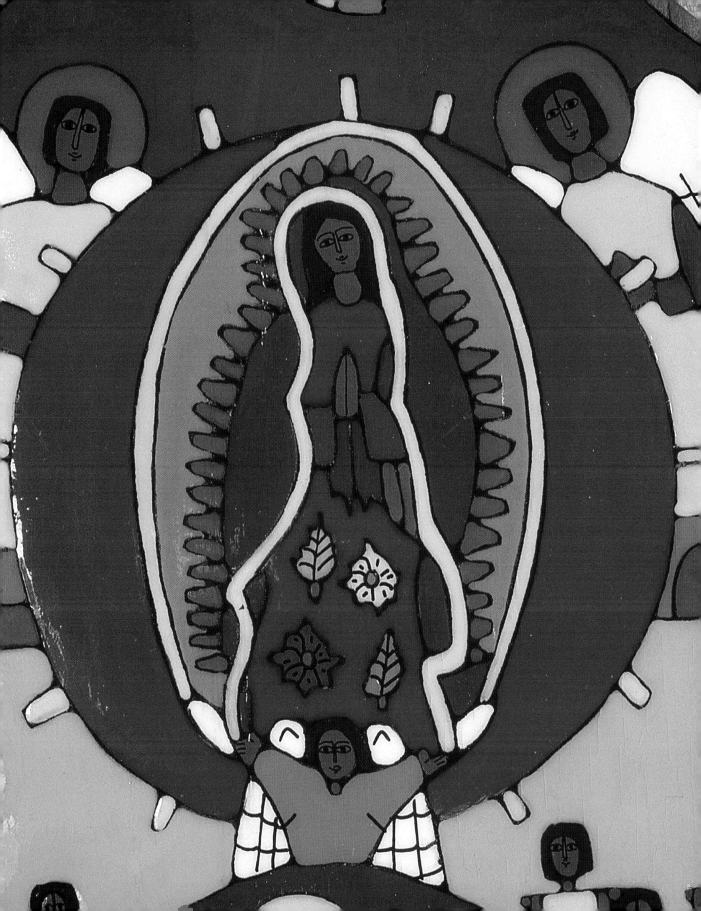

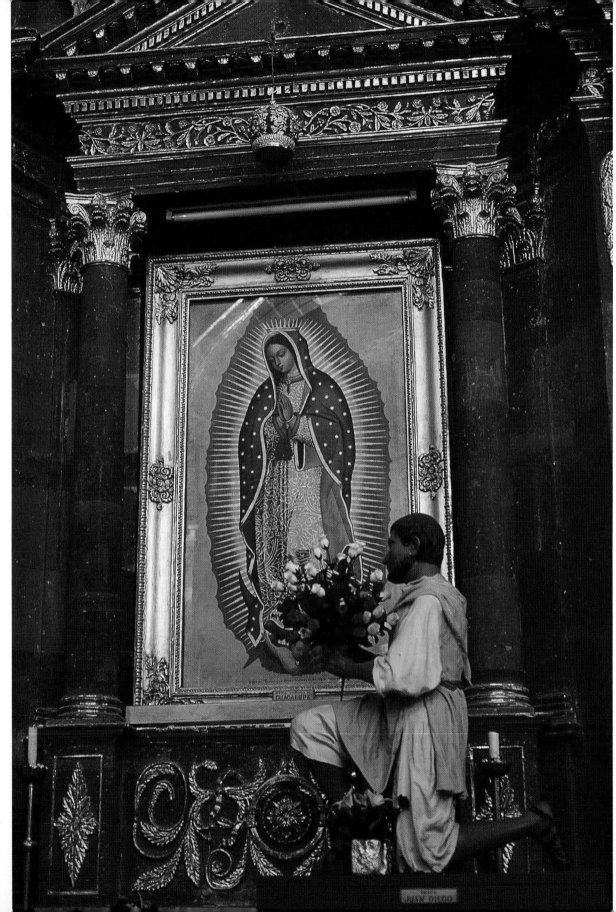

# Juan Diego and the Fourth Apparition of the Virgin of Guadalupe

"And immediately he came back down, he came to bring the Heavenly Maiden the different kinds of flowers he had gone up to cut. And when she saw them, she took them with her precious hands; Then she put them all together into the hollow of his ayate again and said: "My youngest and dearest son, these different kinds of flowers are the proof, the sign you will take to the bishop; You will tell him from me that he is to see in them my desire, and therefore he is to carry out my wish, my will."

—Antonio Valeriano, 1556

*Nicān Mopōhua*, "Here It Is Told" lines 134–8

The Virgin of Guadalupe and Juan Diego, altar (Saint Juan Diego Cuahtlatoatzin), San Miguel Arcangel Parochial Church, San Miguel de Allende, Guanajuato, Mexico.

*La Virgen de Guadalupe y Juan Diego, altar (Santo Juan Diego Cuahtlatoatzin), Parroquía de San Miguel Arcángel, San Miguel de Allende, Guanajuato, México.*

The Virgin of Guadalupe, tile image set
in a colonial stone wall, Hacienda de San
Antonio El Puente Chapel, Xochitepec,
Morelos, Mexico.

*La Virgen de Guadalupe, imagen en azulejo
colocada en pared colonial de piedra, Capilla de
la Hacienda San Antonio El Puente, Xochitepec,
Morelos, México.*

✠

# The Cry for Independence

*"Will you be slaves of Napoleon*
*or will you as patriots defend your religion,*
*your hearths and your rights?*
*We will defend to the utmost!*
*Long live religion,*
*long live our most holy Mother of Guadalupe!*
*Long live America!*
*Death to bad government,*
*and death to the Gachupines!"*

—Padre Miguel Hidalgo y Costilla, September 16, 1810

*El Grito de Dolores*, "The Cry of Dolores"

The Virgin of Guadalupe, gold altar,
Our Lady of Suffering Parochial Church,
Dolores Hidalgo, Guanajuato, Mexico.

*La Virgen de Guadalupe, altar de oro,*
*Parroquía de Nuestra Señora de los Dolores,*
*Dolores Hidalgo, Guanajuato, México.*

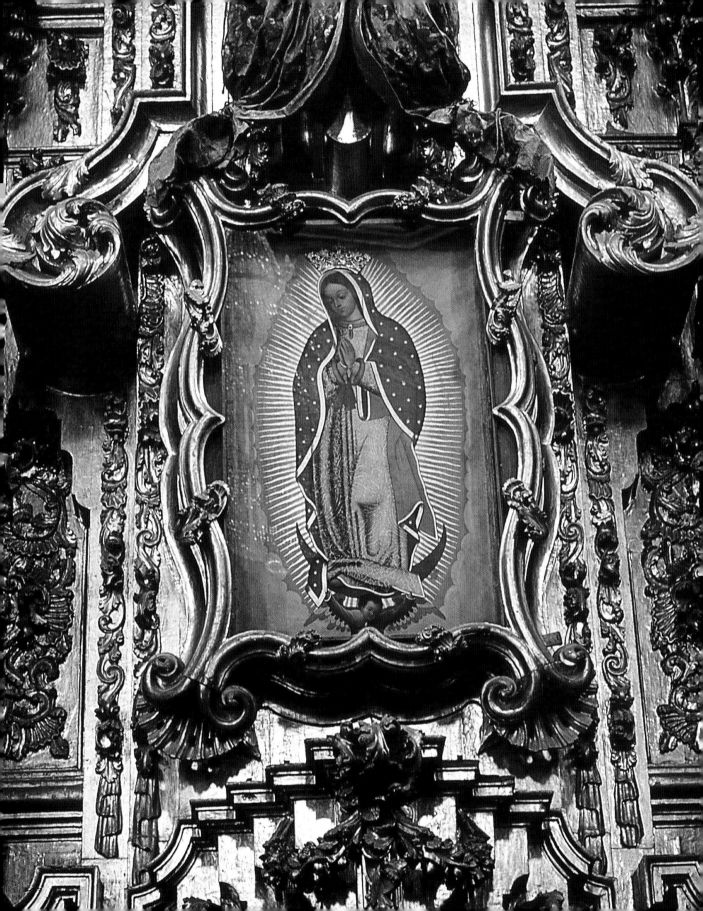

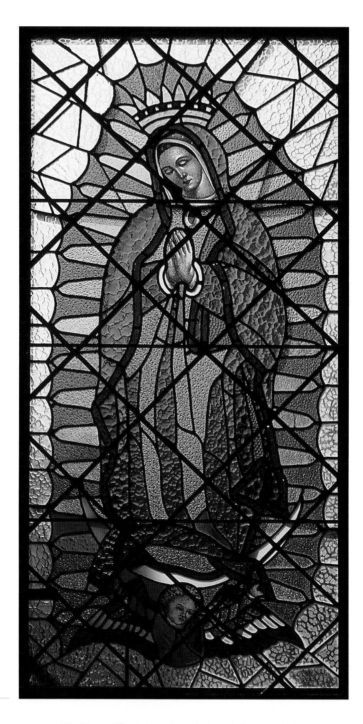

The Virgin of Guadalupe, stained glass window, Our Lady
of Guadalupe Sanctuary, Irapuato, Guanajuato, Mexico.

*La Virgen de Guadalupe, vitral, Santuario de Nuestra Señora
de Guadalupe (del Centro), Irapuato, Guanajuato, México.*

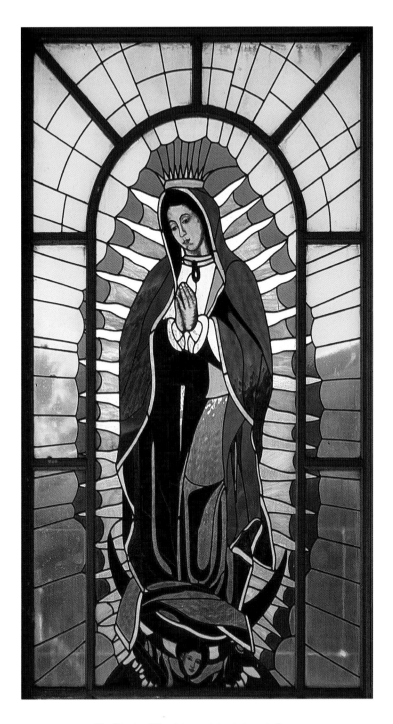

The Virgin of Guadalupe, stained glass window,
Palomas Church, Palomas, Chihuahua, Mexico.

*La Virgen de Guadalupe, vitral, Iglesia de Palomas,*
*Puerto Palomas de Villa, Chihuahua, México.*

✠

# A Revelation

*"[There] appeared in the sky a great signal:*
*a woman clothed with the sun,*
*with a moon under her feet,*
*and over her head a crown of twelve stars."*

—Casiodoro de Reina, 1569

Revelation 12:1, *La Biblia* antigua

The Virgin of the Angels,
facade statues, Our Lady of
Loneliness Parochial Church,
Irapuato, Guanajuato, México.

*La Virgen de Los Ángeles, estatuas*
*de la fachada de la Parroquia de*
*Nuestra Señora de la Soledad,*
*Irapuato, Guanajuato, México.*

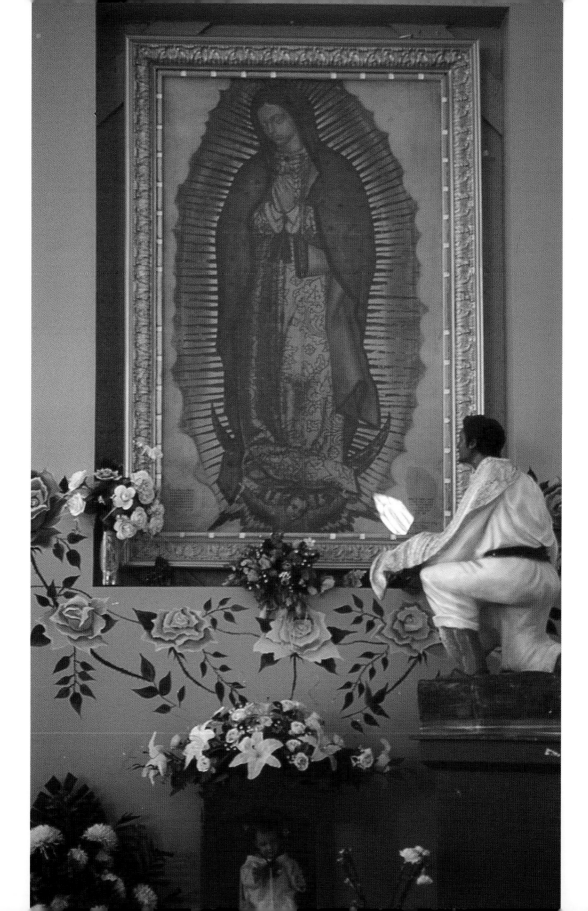

<div style="text-align:center">✠</div>

# LITERATURE CITED

## TEXT

P. 9. Valeriano, Antonio. *Nicān Mopōhua*. México, s.n., 1556. New York Public Library, Stephen A. Schwarzman Building, ms., 16 pages. The earliest known source of the *Nicān Mopōhua*, "Here It Is Told," 1556. Anonymous English translation, 2011 online, line 8.

P. 10. Jiménez, José Alfredo. *Camino de Guanajuato*, (arranged by Rueben Fuentes Gassón). Camino de Guanajuato a Dolores Hidalgo, Rancho de Enmedio, Sierra de Santa Rosa, Guanajuato, México.

P. 14. *Footnote: The name and location of this church has been publicly disclosed elsewhere.

P. 15. Cather, Willa. *Death Comes for the Archbishop*. New York: Alfred Knopf, 1927, p. 50.

P. 16. Valeriano, 1556, anon. trans., lines 16–20.

P. 17. Valeriano, 1556, anon. trans., lines 135–37.

P. 18. Alec-Tweedle, Mrs. (Ethel). "Celebration of the Great Saint of Guadalupe," VII, 100–15, *Mexico as I Saw It*. London: Hurst & Blackett, 1901, p. 112.

P. 18. Sánchez, Miguel. *Imagen de la Virgen María, Madre de Dios de Guadalupe*. México: Viuda de Bernardo Calderón, 1648.

Ps. 18–19. Cabrera, Miguel Mateo Maldonado y. *Maravilla Americana y conjunto de raras maravillas observadas con la dirección de las reglas de artes de la pintura en la prodigiosa imagen de Nuestra Señora de Guadalupe de México*. Ciudad de México: Imprenta de Real y Más Antiguo Colegio de San Ildefonso, 1756.

P. 23. Hallenbeck, Cleve, and Juanita H. Williams. *Legends of the Spanish Southwest*. Glendale, CA: Arthur H. Clark Co., 1938, p. 310.

The Virgin of Guadalupe and Juan Diego, altar (Saint Juan Diego Cuahtlatoatzin), Palomas Church altar, Chihuahua, Mexico.

*La Virgen de Guadalupe y Juan Diego (Santo Juan Diego Cuahtlatoatzin), altar de Iglesia de Palomas, Puerto Palomas de Villa, Chihuahua, México.*

# Photo

Page 17. Demarest, Donald, and Coley Taylor. "Corrido de las Apariciones de la Virgen de Guadalupe" by Silvino C. N. Martínez, 1954, in *The Dark Virgin: The Book of Our Lady of Guadalupe, A Documentary Anthology.* Freeport, MA: Coley Taylor, Inc., 1956, ps. 208–11.

Page 34. Lasso de la Vega, Luis. "The Great Event." *Huei tlamahuiçoltica omonexiti in ilhuicac tlatocaçihuapilli Santa María totlaçonantzin Guadalupe in nican huei altepenahuac México itocayocan Tepeyacac.* México: Impresora de Juan Ruíz, 1649, 36 pages.

Page 39. Inés de la Cruz, Sor Juana. "Poetic Praise to the Father Francisco de Castro," in *Poemas de la única poetisa americana; musa decima. Soror Juana Inés de la Cruz, Religiosa Professa en el Monasterio de San Geronimo de la Imperial Ciudad de México.* "Soneto, Alaba el Numen Poetico del Padre Francisco de Castro, de la Compañia de Jesús, en un Poema heroyco, en que descrive la Aparición milagrosa de Nuestra Señora de Guadalupe de Mexico, que pide la luz publica." Zaragoza, España: Manuel Román, Impresora de la Universidad, Año de M.DC. LXXXII. [1682.] *Tercera Impresión,* p. 205.

Page 43. Martín, Juana García. *El Testamento de la Hija de Juan García Martín,* March 11, 1559, ms., Public Library of New York (translated by Faustino Galicia Chimalpopoca). Cfr Mariano Cuevas, Álbum Histórico Guadalupano del Centenario. México: Escuela Tipográfico Salesiana, 1930, ps. 85–6.

Page 48. Valeriano, 1556, anon. trans., lines 16–20.

Page 59. Manje, Juan Mateo. *Unknown Arizona and Sonora, 1693–1721;* from the Francisco Fernández del Castillo version of *Luz de Tierra Incógnita;* an English translation of pt. 2, by Harry J. Karns and Associates. Tucson: Arizona Silhouettes, 1954, p. 266.

Page 64. Cather, Willa . . . 1927, Chapter 2, "Hidden Water." Project Gutenberg.

Page 69. Sahagún, Fray Bernardino de. *Códice Florentino. Historia de las Cosas de Nueva España.* México, s.n., 1580, p. 299.

Page 71. Shapcote, Emily Mary, "The World's Salvation," in *Mary: The Perfect Woman, One Hundred and Fifty Rhythms in Honor of the Mystical Life of Our Lady.* Philadelphia, PA: The Dolphin Press, 1904, p. 12.

Page 74. Clavijero, Abbé D. Francesco Saverio. *The History of Mexico, Collected from Spanish and Mexican Historians, from Manuscripts and Ancient Paintings of the Indians* (translated from Italian by Charles Cullen). London: G.G.J. and J. Robinson, 1787. Volume II, Book VI, "The Greater Temple of Mexico," p. 24.

Page 78. Hallenbeck, Cleve, and Juanita H. Williams. *Legends of the Spanish Southwest.* Glendale, CA: Arthur H. Clark Co., 1938, p. 310.

Page 83. Bierhorst, John. *Teponazcuicatl,* "The Procession of the Drum," anonymous Aztec song, in *Cantares Mexicanos: Songs of the Aztecs, Translated from Nahuatl, with an Introduction and Commentary.* Stanford, CA: Stanford University Press, 1985, p. 221.

Page 84. Northrop, F.S.C. *The Meeting of East and West: An Inquiry Concerning World Understanding.* New York: The MacMillan Co., 1946, p. 25.

Page 91. Valeriano, 1556, anon. trans., line 22.

Page 99. Valeriano, Antonio, 1556, *Nicān Mopōhua: The Original XVI Century Guadalupe's Apparitions Story.* Anonymous English translation, 2011 online, lines 134–138.

Page 103. Cloud, William F. *El Grito de Dolores,* "The Cry of Dolores," attributed to Padre Miguel Hidalgo y Costilla, September 16, 1810, in *Church and State or Mexican Politics from Cortez to Diaz.* Kansas City, MO: Peck & Clark, Printers, 1896, p. 54.

Page 107. Reina, Casiodoro de. *La Biblia, Que Es, Los Sacros Libros del Viejo y Nuevo Testamento, Traslada de Español,* "Revelación 12:1." Basel, Switzerland: Imprenta del Autor, 1569, Revelation 12.1.

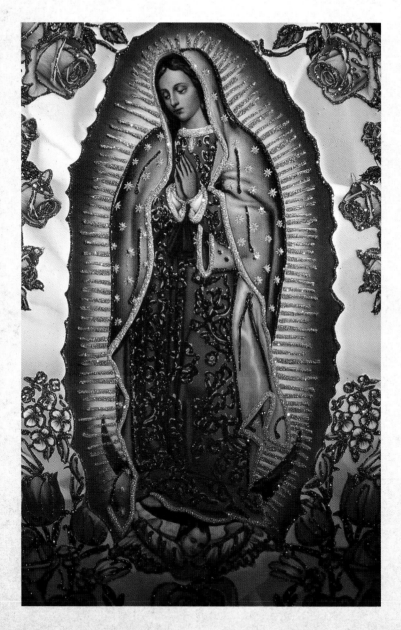

The Virgin of Guadalupe, street image outside of Our Lady of Guadalupe
Cathedral, Tijuana, Northern Baja California, Mexico.

*La Virgen de Guadalupe, imagen en la calle afuera de la Catedral de Nuestra
Señora de Guadalupe, Tijuana, Baja California Norte, México.*